Bloodroot

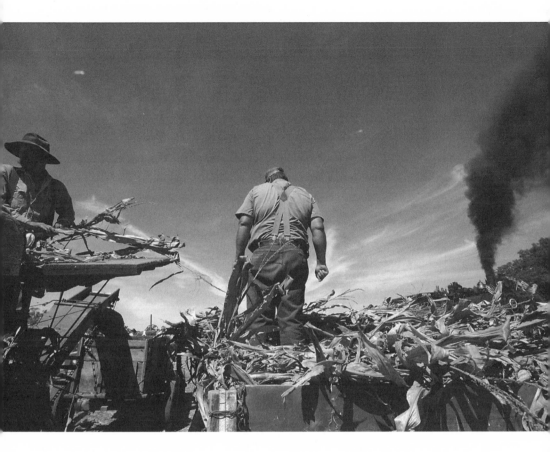

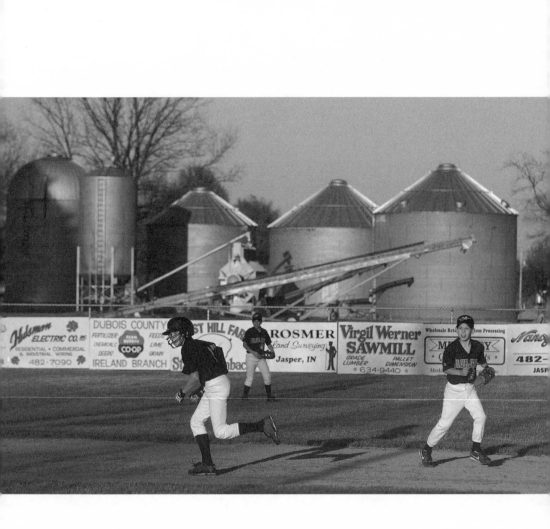

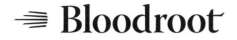

Bloodroot

Indiana Poems

Poems by Norbert Krapf

Photographs by David Pierini

QUARRY BOOKS

an imprint of
Indiana University Press
Bloomington & Indianapolis

This book is a publication of

Quarry Books
an imprint of
Indiana University Press
601 North Morton Street
Bloomington, IN 47404-3797 USA

http://iupress.indiana.edu

Telephone orders 800-842-6796
Fax orders 812-855-7931
Orders by e-mail iuporder@indiana.edu

The paper used in this publication meets the minimum requirements of
American National Standard for Information Sciences—Permanence of Pa-
per for Printed Library Materials, ANSI Z39.48-1984.

Manufactured in the United States of America

Library of Congress Cataloging-in-Publication Data

Krapf, Norbert, date
 Bloodroot : Indiana poems / poems by Norbert Krapf ; photographs by
David Pierini.
 p. cm.
 ISBN 978-0-253-35224-8 (pbk. : alk. paper) 1. Indiana—Poetry. I. Title.
 PS3561.R27B535 2008
 811'.54—dc22
 2008013742

1 2 3 4 5 13 12 11 10 09 08

I dedicate this book to
Jakob and Margarethe Schmitt and their six children,
of Lohr am Main,
and Michel and Elisabeth Krapf and their five children,
of Tugendorf,
both in Lower Franconia, some twenty miles apart,

in honor of their voyages to the United States
from Bremen on the ship America, *1840 (Baltimore)*
and from Le Havre on the ship Louis Phillipe, *1846 (New York)*
and their journeys, one step at a time,
into the southern Indiana wilderness.

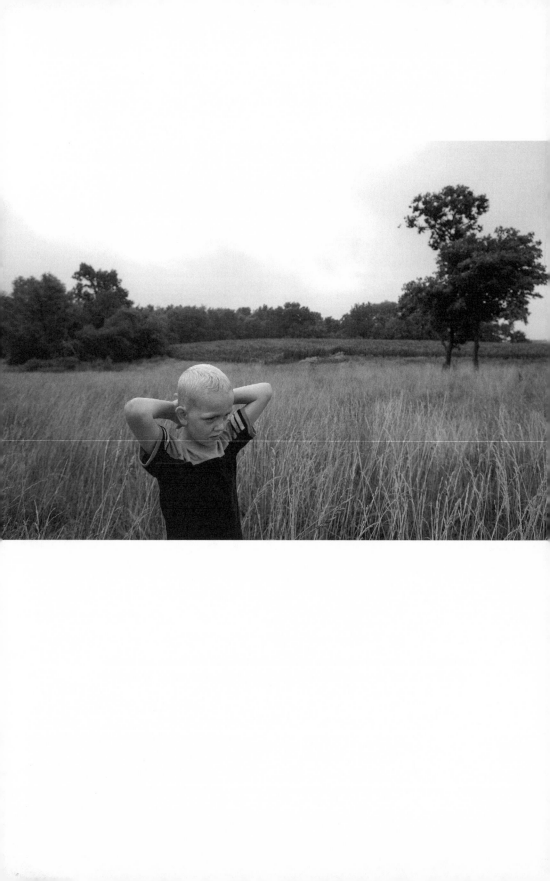

One's native ground is the place where, since before you had words for such knowledge, you have known the smells, the seasons, the birds and beasts, the human voices, the houses, the ways of working, the lay of the land, and the quality of light. It is the landscape you learn before you retreat inside the illusion of your skin. You may love the place if you flourished there, or hate the place if you suffered there. But love it or hate it, you cannot shake free. Even if you move to the antipodes, even if you become intimate with new landscapes, you still bear the impression of that first ground.

 Scott Russell Sanders, Staying Put *(1993)*

You have roots in a place, or you don't; you can't force them.
It helps to be born there, though that's not your choice to make.
But there are things you do that feed and strengthen those roots.
The four best root fertilizers you can give in your lifetime are sweat and blood and tears and ashes . . .
And . . . you can die in that place, and if that is the place where you *want* to die, then that's really where your roots are.

 James Alexander Thom, The Spirit of the
 Place: Indiana Hill Country *(1995)*

Second rule for the fierce writer: Know this—every place on earth is filled with stories, with layers of forgotten history. It's Checkhov's brilliance or Alice Munro's or Thomas Hardy's or Welty's or Kimmel's or Faulkner's or Flannery O'Connor's—regionalists all—to excavate those layers and include them in one human story. To deny invisibility. In the Midwest, we need to work at being fierce.

 Susan Neville, Sailing the Inland Sea: On
 Writing, Literature, and Land *(2007)*

Participating in an art, although unrewarded by wealth or fame, and as the Middle West has encouraged so many of its young to discover for themselves, is a way to make one's soul grow.

 Kurt Vonnegut, "To Be a Native Middle-Westerner" *(2006)*

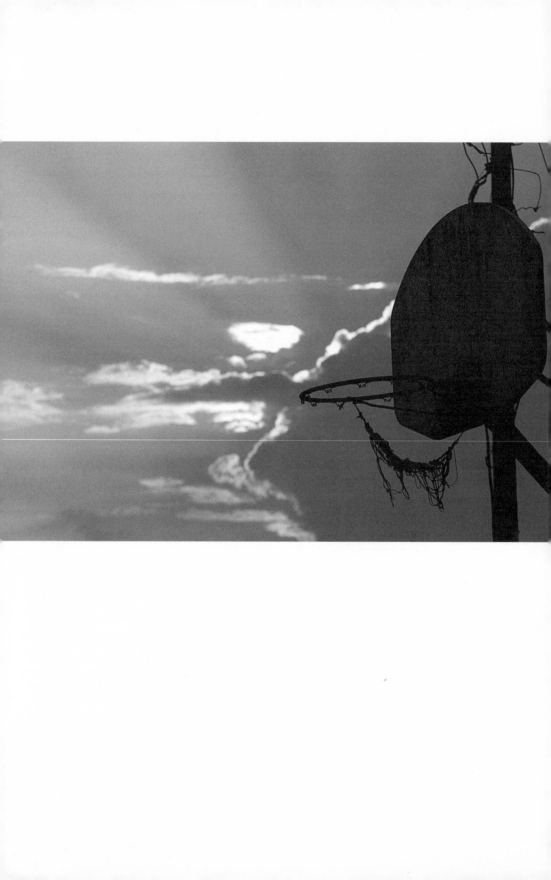

Contents

☰ 3 From *The Country I Come From* (2002)

⇒ 4 From *Looking for God's Country* (2005)

⇒ 5 From *Invisible Presence* (2006)

⟹ 6 *Local News: Poems 2005–2007*

Foreword

Most any poem by Norbert Krapf is vivid, visual and sensuous, even if it describes something as homely as a hog-butchering.

When a wide collection of his poems comes forth, all the poems become the context for each one, and the whole work rides on deep undercurrents of time, place, ancestry, and work.

Krapf's first immigrant forebear steps off the ship into a new country; his children "cling to the man's coat like cockleburs," as he begins leading them to the heartland of a dark continent whose very birds and trees are as new and strange to him as the language. That immigrant is as plainly purposeful as is the sycamore tree in another poem, a bottomland species of tree seemingly out of place up on a hillside. As the immigrant puts down one foot at a time, he is as much home-seeking as the sycamore's roots probing down to suck up the waters of "the ancient swamp beneath the park."

Krapf's own homeland is Jasper, Indiana, where he was born in 1943, but within that homeland there is all the old, stolid, industrious Germanness the early members of the community brought over with them. And the poet's scholastic career has kept him steeped in the old country, where he has served twice as a Fulbright Professor of Poetry. Among the twenty books he has written or edited, two are translations from German and one is a book of his own poetry about Germany.

Thus, Krapf's spirit of place can be specifically local and immediate while encompassing centuries and other homelands.

The people in his poems work with their hands, and they understand how plants live and how to turn a chicken from a live bird into a meal without being maudlin about it. They hold life sacred but don't go around proclaiming that it is.

The test of "poetry of place" is whether it feels perfectly familiar to a reader who lives there. This reader is a southern Indiana native who feels right at home in Norbert Krapf's poems.

James Alexander Thom

Preface

For many years, I resisted the temptation to put together a volume of selected poems. It is best, as I could see from examples to the contrary, not to bring out such a retrospective collection before a substantial body of work has appeared. Furthermore, I was not confident I could create a coherent selection of poems from volumes set in southern Indiana, where I was born and grew up; southern Germany, where my ancestors lived; and Long Island, where I lived much of my adult life. To shape a unified whole of poems set in these geographically distant spiritual centers of my work loomed as an overwhelming task.

When I moved back to Indiana from the East Coast in 2004, however, new poems set in my native region came even more frequently, and in greater numbers, than ever before. In early 2005, I began a collaboration with the superb Indiana photographer Darryl Jones that led to the publication of *Invisible Presence* (2006). When that book appeared, it became apparent that a selection of Indiana poems, written 1971–2007, was not only justified, but would represent the core of my work as a poet.

Bloodroot: Indiana Poems gathers 175 poems, including forty new ones written after those that appeared in *Invisible Presence.* Speaking to one another, and as a collective whole, these poems voice my central concerns and articulate my major allegiances. I have been blessed to return, in my sixties, to live in the region that for so long served, at a distance, as my most constant source of inspiration. *Bloodroot* brings together the essential poems rooted in my native place that engage the details of the natural and human history—the external and internal cosmos—of the landscape that I was given as a birthright.

This book represents the kind of homecoming any poet would welcome and gladly share with readers. To have these poems so luminously illustrated by the photographs of David Pierini, who worked for ten years at *The Herald* in my hometown, Jasper, deepens the satisfaction of presenting a body of work rooted in the region that has been my familiar yet mysterious universe to explore.

Norbert Krapf
Indianapolis

Acknowledgments

All the poems in parts 1 and 4 are from *Somewhere in Southern Indiana: Poems of Midwestern Origins* (1993) and *Looking for God's Country* (2005), © Time Being Books 1993, 2005, and are reprinted by permission of the publisher. The poems in parts 2, 3, and 5 are from *Bittersweet Along the Expressway: Poems of Long Island* (Waterline Books, 2000), *The Country I Come From* (Archer Books, 2002), and *Invisible Presence: A Walk through Indiana in Photographs and Poems,* with Darryl Jones (Quarry Books, 2006), © Norbert Krapf 2000, 2006, 2006.

The new poems from part 6 listed here originally appeared, sometimes in different form, in the following publications: *Animus:* "Charlie"; *A Prairie Journal:* "The Call of the Quail"; *Blueline:* "Clothesline Saga," "Sister Soap"; *Branches:* "Woods Chapel," "A Bend in the Road"; *From the Edge of the Prairie:* "Etheridge Knight at the Chatterbox," "Fiddler," "I'm Practically with the Band," "Old Henry," "Palm Light," "On the Road with the Hampton Sisters," "Rustic Tavern"; *Heartlands:* "Wilson's Drugstore"; *Rogue Scholars:* "Etheridge Knight's Blues"; *Seventh Quarry* (Wales): "Teach Me, Father"; *The Tipton Poetry Journal:* "Dolls and Guns"; *Valparaiso Review:* "The Blueberry Bush."

Under the title "Back Home," section 2 of "In Transit" was selected by English artist Martin Donlin and incorporated into a stained-glass panel he created for the Indianapolis International Airport opening in October 2008. "Deaton's Woods," "Etheridge Knight's Blues," "Fire and Ice," "On the Road with the Hampton Sisters," and "What Have You Gone and Done" were included on the CD with Monika Herzig, *Imagine—Indiana in Music and Words* (Acme Records, 2007). Thanks to George Vecsey for including part of "Prayer to Peyton Manning" in his January 28, 2006 *New York Times* column, "One Man's Ode to Indianapolis," and to all the editors of the above publications for giving these poems a prior life.

The author and photographer would also like to thank Linda Oblack for the suggestion to make this a book illustrated with photographs.

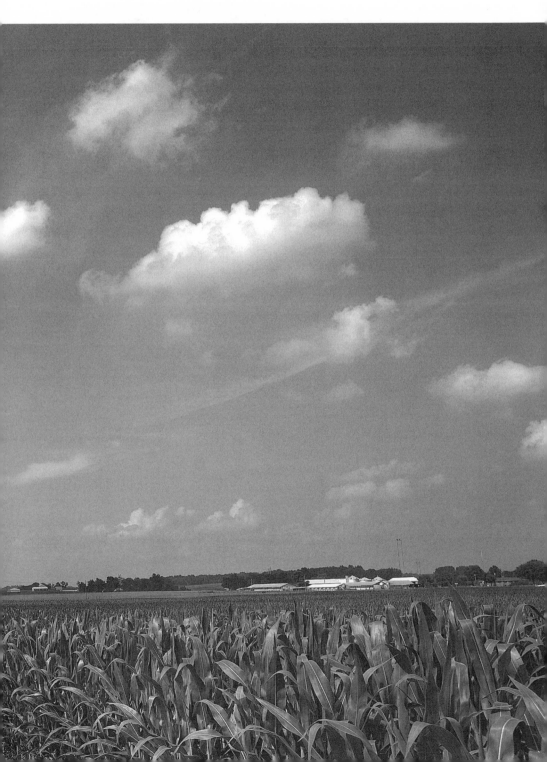

Bloodroot

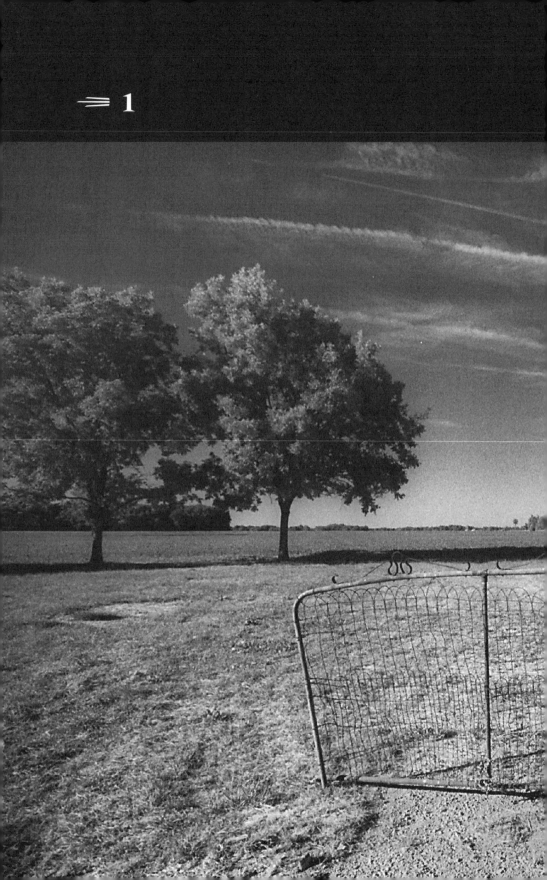

From *Somewhere in Southern Indiana* (1993)

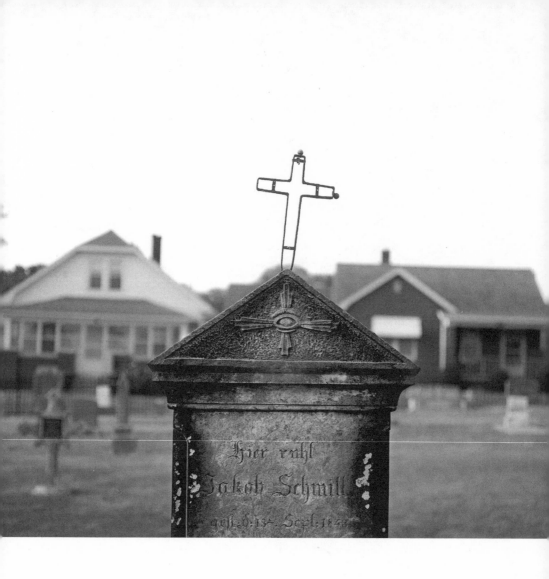

The Forefather Arrives

He stumbles off the ship *America,*
parts from the people who
speak the only tongue he's
ever known, and leads a wife
and six children toward the middle
of a dark continent. Eight
pairs of shoes shaped
by the contours of cobbled
Bavarian streets must soon
begin to fall evenly upon
uncultivated ground. Like
a startled rabbit, the woman
cocks her ears for the pealing
of distant church bells.
The children cling to the man's
overcoat like cockleburrs.
A sailor whose eyes blink
back to the vineyards patching
the banks of the Main River,
he knows he must learn to
navigate this foreign land
by foot. He stares at the bark
of trees he's never seen,
flinches at the songs
of birds he's never heard.
He worries about laying seed
in the soil in the spring.
He sucks in his breath,
puts down one foot at a time.

Entering the Southern Indiana Wilderness

As they prepare to step on land,
the Ohio River swirls and heaves
darkly beneath them. Soon he
and his family try to tread
hilly terrain flooded in shade.
No Franconian sunlight lifts
them to buoyancy. Hazy leaves
spindling at the top of sycamore
and tulip poplar seven feet thick
float one hundred fifty feet
above his head. Even at noon
he feels sunk in twilight.
Like a fish channeled into
a strange sea, he quivers along
a trail the buffalo had drummed
onto the forest floor. Deer paths
intersect the trail, then slither
like water moccasins into the darkness.
He runs his fingertips along
the gashes the black bear
clawed like a foreign alphabet
into the bark of sugar maples.
He observes the hills and streams
sloping southwesterly back toward
the Ohio. He feels he is swimming
upstream, toward an alien source.

Butchering: After a Family Photograph

in memory of my grandmother,
Mary Hoffman Schmitt, 1883–1977

In front of the weathered smokehouse
the scaled hogs hang, hind feet
tied to an ash sapling wedged
between forks in the framing maples.
The squeals of animals dying have
long since frozen into silence.
Snouts have dripped circles of blood
onto a sheet of January snow.
In a field behind the smokehouse
(out of range of the camera eye)
the women empty intestines thin
as onion skin for casings while
other innards boil in iron pots.
Carving at a carcass in the middle
of the picture, the men half turn
and frown as if to say: "We kill
to survive. Starvation lurks just
down the road. We have no time
for your art or your sentimentality."
The man in overalls and boots who
squints the hardest is my grandfather,
thirty-three. Three years later,
on doctor's advice, he took a walk.
Zero-degree breezes fanned the flames
of consumption hidden in his chest.
Two weeks later he lay in cold earth.

Cutting Wood: After a Family Photograph

in memory of my father

The steam engine clatters
in a frosted hollow of southern
Indiana hills. White puffs of steam
hang above a hedgerow of bare trees
in the background. You stand there,
grandfather, the ends of your moustache
curling about the corners of unsmiling
lips, gazing at the circular saw about
to bite into the green pulp of a log.
I feel in my blood your reverence
for the medium of wood, respect
your demand for the precise cut.

For twenty-five years your son
crafted processed wood into chairs.
He often stared at the grains
in woods. Now I, who remember
touching your hand only once before
you died in my third year, sit behind
a desk and daydream of the forests
that fed your saw. Soon after you
lay in the earth, your son led me
into the woods and cupped my ears
to the leafy murmurs of shagbark hickory,
wild cherry, oak, and beech. He taught
me how to kill for food the animals
that fed on the fruits of those trees.

One summer's work in a wood factory
still has me running my fingertips
over the finished grains of woods
your rough saw once cut into lumber.
With your love of the precise cut,
grandfather, you would understand

my need to carve with a pen
a line smooth and delicate as wild
cherry, yet tough and durable
as hickory. I glide over sawdust
toward you, with the shadow
of the anonymous photographer
caught in his picture.

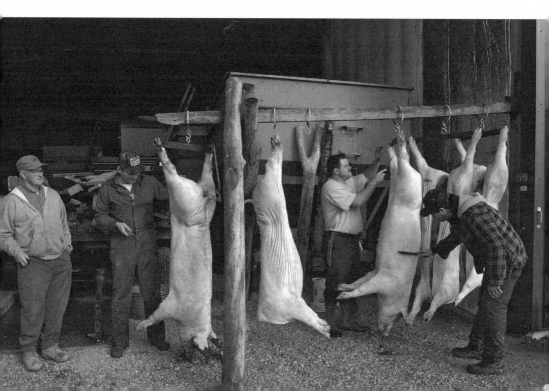

The Woods of Southern Indiana

The woods of southern Indiana
are filled with wild animals
that roam all night. When lights
go out in farmhouses, they creep
out of woods, explore barnyards,
sniff garbage cans, raid chicken
pens, drift back into the hills
at the first hint of light.

When I moved away from southern
Indiana, a part of me broke loose
and joined those wild animals.
No one has ever been able to
track me down. Once in a while
a night hunter will catch a glimpse
of my eyes when he flashes his
light in the branches of a beech.
Every farmer seems to have one
hound in his barnyard that barks
one dark night a year, then curls
up and sleeps through the day.
Whenever the Patoka River floods
the bottom lands, then drains,
my tracks have been found caked
in the mud between rows of corn.

Once when I returned to the scenes
of my youth, I walked deep into
the forest, stood beneath a shagbark
hickory from which I had shot squirrels,
saw several branches bend, and tingled
as a speck of fur flew from the tree.

Sometimes reading my own poems late
at night, I seem to perceive tracks
of my former self between my darkest
lines, but I have never been able
to match the feet that carried me
here with the prints I detect there.

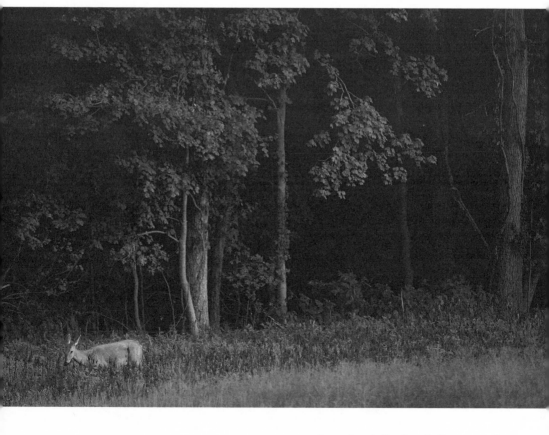

Indigo Bunting

Back when I was
as convinced as only
a young skeptic can be

that I would never meet
anyone to fall in love with

would never wake up
between warm sheets
breathing in unison
with the right woman

would certainly never marry

couldn't conceivably know
the pleasure of looking
deep into the eyes
of a son or daughter

I was walking alone
along a winding rock road
in my beloved hills
of southern Indiana.

I was kicking rocks
with my right foot
into dry Queen Anne's lace
in the hot August sun.

A faint whir skimmed
across those flat
tops of snowy white.

I looked up just in time

to see a streak of blue
so pure and sweet
I thought I had never
looked up at the sky.

For the first time,
my friend, I was
ashamed of my certainty.

This blue is for you.

Chamomile

Along the border
of an Indiana garden
beside a cold frame

my great-grandparents
cultivated you for
the herb-blossom tea
they believed cured
most of their ills.

Oh calmer of nerves
and delirium tremens,
soother of headaches
and preventer of nightmares,
repeller of insects
and softener of hair

Oh spirit whose steamed
essence unclogged
my infected sinuses
in the Black Forest
and eased my eyelids
toward sleep

may your feathery
foliage and sunburst
flowers flourish in
the herb garden outside
the kitchen window.

Purple Trillium

Three petals,
three sepals,
three leaves.

Herb Trinity,
Trinity Lilly,
Wake Robin,

your liver-red
flower blooms
when robins
return north.

North Shade,
you love dank
humus and shadows
of trees.

Squaw Root,
Stinking Benjamin,

your maroon flower
gives off a fetor
to those who
come near.

My mother found
you instead of
"revenoors" when
she sneaked back
to the woods
behind the Indiana
farmhouse to stir
a kettle of corn mash.

Women have said
you help bring
on their monthly
flow of blood.

Birth Root,
you supposedly
ease the birth
of babes.

Trillium Erectum,
whose womanly flower
stands up on
a short stalk
above veined leaves,

stand straight
and stiff
in my garden.

In the name
of your petals
and sepals
and leaves
amen.

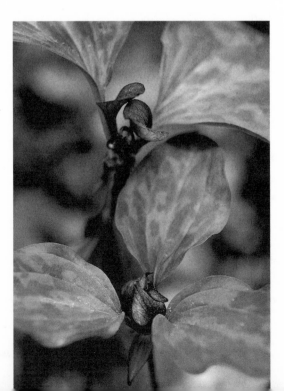

Tulip Poplar

You rise like
a classical column
above a ceiling
of secular leaves

gray bark
paling in grooves
around straight-
grained wood out
of which Indians
carved canoes

and my forefathers
framed an Indiana
homestead on a hill
and a courthouse
on the town square.

Your wide, four-
pointed leaves
notched at the tip
billow in the distance
like the sails
of immigrant ships.

≈

I come to touch
the twin flames
of love and memory
of those who
came before
and disappeared
into the dark

to the delicate
candle that rises

out of a sac
of pollen

in the center
of your lime-
green tulip-
shaped flower.

Walnut

Loner, you stand
your own ground
as if to deepen
the mystery of
your darkness.

I have felt
the push of
your grain against
my shoulder in
the stock of
a double barrel
as I fired
into your limbs
blocking the sun.

As a boy
I filled gunny
sacks with your
lobed green fruit

hammered husks
against a brick

went to school
and hid stained
fingers beneath
a desk top.

Now staring
into a refinished
veneer of your
earthen grain

I press a pencil
with pale fingers
back and forth
across papers

to conjure
your shadows.

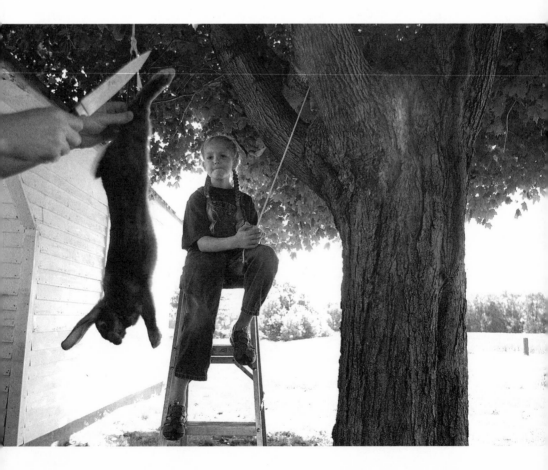

Skinning a Rabbit

I rip off
bobtail
pull fur
down back
peeling it
over belly
yank it
over head
across paws
drop it on
old newspaper
insert knife
where naked legs
spread apart
slash down
through tender belly
as thin blood
drips drips
and guts bulge
stick hand
into slit
grab handfuls
of warm guts
which I tear
from back
chop head and paws
off with hatchet
plop whole wad
on top of fur
wrap corners
of newspaper
around bloody mess
compress it
into ball
to bury in garden

drop leftover flesh
in pail of water—

staring down
at a shriveled
pink embryo
in reddening water
I blink to
the large streaking blur
my shotgun
blasted so still
and wonder why
I pulled the trigger
with such fever
the knife
with such relish
the guts
with such satisfaction.

Darkness Comes to the Woods

It begins to trickle
silently onto the floor
of the far side
of the woods which
the hunter cannot see.
First the creatures
dog-paddle in it, then
turn and float on their
backs as it creeps up
the bark of trees, pressing
down heavier and harder
on everything below.
Eventually the hunter
hears it lapping, then
breaking, then thundering
toward him. He turns
his back, splashes to
the field outside, looks
back on pairs of glowing
eyes gliding below
the surface of pitch-
black waters which have
swollen to the treetops.

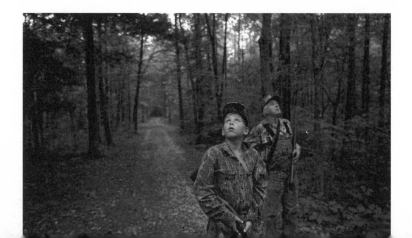

Southern Indiana

And the hills roll
as they always have
and somewhere in the woods
that bend and wrap around
those hills the bark splits
from the trunk of a shagbark
hickory and a fox squirrel
drops a patter of cuttings
through crisp oversized leaves
as a boy with a shotgun
on his shoulder cocks ears
and trains eyes for a glimpse
of red fur between the parting
of green and at the edge
of the woods where dried
corn rustles in the breeze
Queen Anne's lace stands
in jagged profusion
and over these hills
that will always roll
a black red-tail hawk
with eyes sharp for
the subtlest gradations
glides in a circle
that will never end.

St. Meinrad Archabbey

As I sit on a bench
beside the flagpole

on a hill of this remote
monastery in southern Indiana

a mockingbird sings a sliding
song within a holly tree.

This song would not seem
so loud and profane

but for the thick
silence surrounding us.

As whispered prayer seems
to push outward from cells

within sandstone buildings
his swiveling notes

fly outward from his
green cloister and glide

down the valley
shrouded in mist.

When he punctuates his
lyric with measured quiet

I conclude that native
song issuing from secluded

places is also one
essential kind of prayer.

To Obscure Men

This is a belated letter
to lonely old men like
the uncle who taught us
how to hunt, the neighbor
who took us on our first
camping trip, or the friend
of our father who organized
the excursion to our first
big-league ball game in
Cincinnati or St. Louis.
This is an inadequate,
belated letter to old men
everywhere who, after we
grew up, moved away from
the town, and never wrote
back, sustained themselves
for a few years on bitter-
sweet memories of laboring
in factories, sweating on
county road gangs, or working
the earth on hand-me-down
farms. . . . A long overdue,
unsuccessful letter to
unhappy old men who withered
away in parlors, hanged
themselves from two-by-four
rafters in garages, or shot
themselves in smokehouses
with the twelve gauges
they'd hunted with for fifty-
five years. . . . An impossibly
late but nevertheless contrite
letter from those of us
who have just grown old
enough to begin to remember.

Two Bricks and a Board

1

After years of moving
from one Franconian village
to another where they
worked other men's fields
as day laborers

after riding a bucking ship
across an untamed ocean
and coming inland
by railroad and river boat
and walking north
along a corduroy road
into the wilderness
they found the right hill
south of the boundary between
Dubois and Spencer Counties.

They looked out over the valley
stretching to the east
and west and envisioned
ripe wheat and barley
rippling in the breezes
on the gentle slopes
and Indian corn taking
a stand in the bottoms.
They heard animals
grunting and cackling
in a barnyard at their back.

They took a long look,
said, *This is the place!*

They bought the land in 1853.
They felled poplars in the forest,
cut and hewed them into beams,
brought bricks from a kiln.
With their own peasant hands
and help from other German

immigrants who came out
of the woods they built their
own farmhouse on this hill
they had come so far to find.

2

Here they celebrated Elisabeth's
wedding to a young man from
another village in Lower Franconia.
Here my great-great grandfather
Michael died in his bed after
deeding the farm to his son Johann.
Here my grandfather Benno was born
who one day walked across the valley
and crossed the county line
to the first farmhouse to the north
and asked my great-grandfather
August Luebbehusen for permission
to take his daughter Mary as his wife.

Here my father brought me
the year before he died to show
me the farmhouse his Uncle Alois
sold out of the family when
he moved to Missouri in 1911.

I stood on the creek-gravel
floor of the cellar, looked up
at a massive oak beam over my head,
stared at the wall three bricks thick.
I stood on the back porch and looked
down at the four-inch poplar saddle
of the doorway leading into the kitchen
worn at least an inch and a half
by the comings and goings
of so many generations. I stood
in the attic and squinted
at fourteen-inch poplar rafters
and thought of the strong hands
that had built this house.

3

I drive west along I-64,
as I always do when I come home,
and go one exit beyond my turn
so that I can see the brick
house again and ground myself.
I am home for the funeral
of the last uncle on my father's
side of the family, the brother
who was his business partner
over a quarter of a century.
More than ever before, I need
to witness the house on the hill.

I recognize the outer buildings
from a distance, but something
is wrong, terribly wrong.
Approaching the hill, I pull
off to the side of the interstate
as trucks roar past. I go
into shock, into a state of denial,
and pass beyond into a grief
you feel only when someone
close has died and you come
to understand you are powerless
to restore him or her to life.

Where the house they built
with their own hands
once stood is a huge
filled-in hole settling
like a fresh grave.

I learn the owners saved some
poplar beams for a new house,
set fire to what they could not use,
and bulldozed the burnt rubble
into a hole that was the cellar.

Friends of our family who live
nearby help me salvage something

to keep: two whitewashed bricks
and a jagged piece of poplar.

4

Blessed are the hands
that hewed this wood
and held these bricks.
Blessed are the names
of Michael, Johann,
and Elisabeth.

Blessed is the story
of their obscure lives
even though nobody
I know can tell me
anything about them.

Damned are those
who have no feeling
for the ones
who came before.

Damned are a people
who forget
as they move
relentlessly forward
into the progress
of the present
without preserving
at least a trace
of the lives
that built and shaped
the heritage
which shelters
and sustains them.

For to live
in the present
without remembering
the past is to

die a slow inhuman
death in a time
that leads nowhere
but back into
itself sealed off
forever from
life to come.

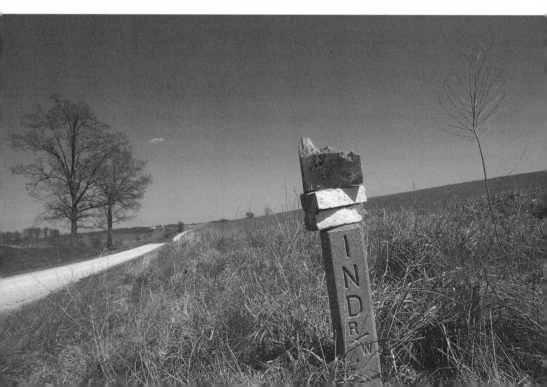

My Father Young Again

My father is young again
in the village of St. Henry,
Indiana that is somehow
no longer almost deserted.

Teamsters hauling freight
from the no-longer
defunct railroad station
in Johnsburg stop again

in the saloon of his
Prussian grandmother
that was torn down
and replaced by
a modern brick house

and they guzzle beer
and eat all they can
for a nickel and somehow
he is able to sleep
one more time the sleep
of the innocent
in the bedroom where
he was born above
the din of card games
and beery laughter.

As he grows older
he rides in the summer
beside his father
on the steam-engine
threshing machine that
has found its way back
into family hands
and cuts a neat swath
through golden-brown
wheat fields that roll
up and down hills.

Evenings he walks
across the lane
into the shadows of
the small wooden church
built by the first German
settlers and watches
the flying squirrels
that have disappeared
glide from one tall
fir tree to another.
He quietly turns his
face and cries when
his father tells him
he must stop school after
the eighth grade because
the nearest high school
cannot be walked to and they
can't afford to buy a horse.

So he guides a plow
behind his hot-headed
uncle's mule for dirt-
cheap wages and room
and board and lessons
in how to curse

but he slips away again
on Saturday nights to
fiddle at barn dances
for a few bits and all
the beer he can drink.

Sunday afternoon he dons
the cap and uniform
of the St. Henry Indians
and spins off the curve
and drop he's perfected
to the applause of spectators
assembled in the pasture

as the last rays of Sunday
sun filter through those
stained-glass windows
of the new village church
for which his father's
sawmill ripped for free
the timber cut from
his neighbors' woods—

in the very church where
I have cupped the sunlight
in my hands after it
flickered through family
names I have seen painted
in rectangles at the bottom
of those windows a short
walk from the cemetery
where familiar names
are carved in stone
in script row after row.

And now that my father
is dead he is still young
and growing younger
and I hold him there
for my children who never
saw him except in pictures

and I safeguard him from
anxiety about the future
and the death of his
younger brother in World
War II and the breakdowns
that robbed him of speech,
deprived him of smiles,
and brought him near a God
he feared would desert him

and I relieve him of
the fear that he would
never marry and know

the bittersweet joy
of raising four children

and I celebrate his perhaps
unwitting sense of irony
in marrying his brother's
former girlfriend who
like a frog in a folktale
turned into the mother
of the son who would
return to the land of his
youth and bring him
back to life once again.

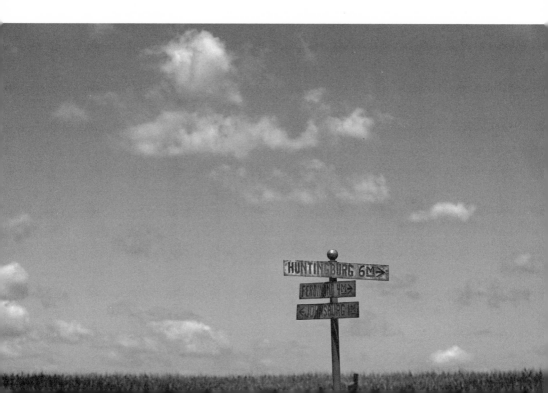

A Terre-Haute Story

It's the night before a wedding.
A table is set in Terre Haute, Indiana.
The last names of the bride and groom
begin with a K; both are solid German names.

The family of the groom is from the hills,
from the country. As small and backwoods
as it may seem to some, to them Terre Haute
is a big city. This dinner party is important.

The rented china and silver, fancy as can be,
glitter in all the artificial light. This
is a scene that might have been dramatized
in a novel by that German son of Terre Haute,

Theodore Dreiser, but you can be sure that
the parents of the groom never read novels.
If asked, the parents of the bride might
pretend to have read Dreiser of Terre Haute.

You must understand that the groom's folks
are country people who squirm when they enter
even a small-town restaurant for fear
of saying or doing the wrong thing.

They do not want to botch this affair.
The table is set, and the food is brought.
Maybe it's roast beef and mashed potatoes
and green beans or peas with a salad.

Whatever their social class, religion,
or profession, Americans of German descent
cannot resist good meat, good potatoes,
and even ordinary beer. Here in what

strikes them as a fancy house in Terre
Haute, Indiana, the night before a wedding,
champagne glasses have already been raised
to a toast by the father of the bride

and drained. As we all know, in our time
only one in two marriages will last. Much
to the eventual anguish of the parents of the groom,
this marriage will not last very long.

Out of courtesy, the father of the bride,
who is Catholic in name only, turns to
the father of the groom, who is as Catholic
as German-Catholic can be, and asks if

he will please say a prayer before
the meal begins. The face of the father
of the groom turns almost as white
as his hair, he looks down at his

china plate, he tries to clear his throat
as if a catfish bone were stuck in it.
There is a painful silence in the big
house in Terre Haute, Indiana. Finally,

the mother of the groom begins to say,
"Bless us oh Lord and these thy gifts,"
and the meal can begin. And years later,
long after my father has died, my mother,

who has still not made peace with the divorce
of her second son, tells her eldest son
the secret of this story about the two German
families from southern Indiana: I knew

that half of each day of the eight and one-
half years that my father went to school was
conducted in German. I knew that my great-
grandfather had been born in Germany,

that my grandfather spoke mostly German,
that my father read and spoke German.
But I had not realized that my father
could speak to God only in German.

Hoosier Songs

1

October sunlight
riding the ripples
of the Wabash
meandering southward
on my right

heart-shaped redbud
leaves burnished
to gold spindling
on the hillside
to my left

I glide like a sea gull
near the seashore
over sunlight and shade
streaking the surface
of winding River Road.

2

Heading due south
dead-center in the state
where I was born

I come home again
to these hills aglow
with October amber

and tall tulip
poplars billow
on the horizon

ivory-shafted
sycamores flutter
in the valleys

and clusters
of sugar maples
flicker and flare

as song rises
from the middle
of the heart.

Sisters

for Mary

My first sister
was born without
ever drawing a
breath. I heard
my mother cry
and my grandmother
scold her upstairs.

When my second sister
began to cry,
my mother breathed
a lot easier. My
grandmother smiled.
The dolls we kept
clapped their hands.

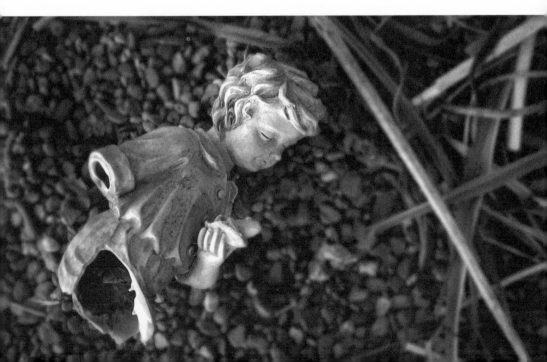

A Civil War Veteran from Indiana Recalls Visiting with Walt Whitman in a Washington Hospital

Even now, as I stare into the fire,
I can see him sitting there, that
lonely old man whose eyes fluttered
like quail roosting beyond the snowy
white bush of his whiskers and hair.
At first when I came to at dusk
and saw him sitting there, through
my fever, I was suspicious. As you
can imagine! What could an old man
want in a ward of wounded and dying
soldiers that reeked of gangrene
and piss? But when he spoke,
I relaxed. I had never heard
such a voice. His words were salve
to my wound. He talked like one
of us, but somehow gentler.
He asked about my pain, if it was
better. I nodded. When I admitted
I was thirsty, he put water to my
lips. He wanted to know where my
folks lived, whether they'd heard
about my injury. When I shook
my head sideways and mumbled "Indiana,
southern Indiana," he said: "Oh, yes,
the hills. A Hoosier from the hills!"
He'd once sailed up the Ohio River
past Troy, he said, on his way back
from New Orleans. He wrote a letter
like I'd never read. It arrived like
balm for my mother's fears, beer
to my father's thirst for news. Mother
saved it till she died. "Don't worry,"
he wrote, "your brave son will be back
eating pawpaws soon." When I got back

enough strength to become a good listener,
he explained he'd gone all the way
from New York to Virginia looking
for his brother George; he'd been wounded
in the first Fredericksburg battle.
My God, how he loved to talk! Sometimes
I wondered who was the patient and who
was the aide. Outside the hospital
at Fredericksburg, he said, he found
"a heap of feet, arms, legs, and hands . . .
Enough to fill a whole horse cart!"
He shook his head, shuddered, and
sort of moaned: "And dead bodies
covered with brown woolen blankets."
He took a deep breath, then sighed:
"But George was alive and whole."
Sometimes when he looked into my eyes
from beyond that white bush, I thought
I might have once been his brother,
in some other world. I was by no means
the only soldier he visited. He'd come
into the ward coat and trouser pockets
bulging with gifts: apples, oranges,
sweet crackers, figs. Once he came
in carrying a jar of preserved raspberries
"donated by a lady." A few times I saw
him slip a coin into someone's moist
palm. Once I saw him lift a twist
of tobacco to an amputees's jaw.
Many's the time I watched him tear off
a sheet of paper from a pad, write
while he asked questions at the side
of the bed, and seal a letter into
an envelope. How that man loved
to write! To people from all over!
You'd have thought he was a parent himself.
He once confessed that he'd written many
a tender love letter for the wounded.
That made him chuckle. The night before

I left, he read to me from a book.
I had never heard anything like it.
It was like the person in that book
was talking right to me, had known
me all my life. He spoke my kind
of language. It was beautiful without
being fancy. It was natural as sun,
rain, and snow. The rhythm swelled
like the sea, as I imagined it to sound.
I could see leaves of grass growing
on the graves of soldiers. I could
see a young boy growing up on an island
with an Indian-sounding name. I could
feel the sun on my shoulders, hear
the surf splash on the shore. When his
voice ebbed like that tide, I looked
into his soft eyes, and told him how
good it was. He smiled, thanked me,
said he wrote the book himself.
Watching the fire fade, I can still
hear his salty voice roll like the sea.

Flight

The onset of adolescence
flushes fidgeting children
like coveys of quail
from brooding parents.

The children fly in formation
over neighborhood fences
toward foreign fields
and light separately

in exotic bushes, but as
soon as they tire of
cramming their craws
with novel berries and seeds

they come winging back
in pairs feeling deep
in their beaks a need
to peck familiar grain.

For an Old Friend

What a cruel way to learn
the news! The hometown newspaper,
arriving well after the fact,
tactfully placed your picture
and story on the second page.
I almost overlooked it that late
Friday afternoon when I settled in,
tired, for the weekend. The same
fine features I remember from ten
years ago, the look of the hometown
boy destined to go far, very far.
But, for whatever reasons, you
came back home from New York.
You came back to the town you
once loved, but could no longer
accommodate your needs, couldn't
even give you the simple urge
to keep on breathing. You were
drinking heavily, I hear. Last
time I saw you, at the town library,
you appeared on the street with
a flushed face, said hello, offered
a nervous hand, hurried back home
through the alley. I still cannot
believe what I read. I cannot
accept even the idea of you
hanging from a belt in the bedroom.
I want to sing you back out
of the darkness, onto your feet.
I want to release the tension
around your throat and sing
the breath of life back into
your lungs, hear that whiplash
wit, listen to deaf Beethoven's
ecstatic last symphony as we

sip from mugs of beer, argue
American literature, discuss
the merits of various cuisines.
But it's no use, Jeff. The poem
is always too much after the fact.

Basketball Season Begins

Except for the throng
buzzing in the gymnasium,
the town might seem deserted.
Tonight no one drives
up or down Main Street.
Soon every factory worker
balanced on the edge
of the bleachers will
know as exactly as his
boss leaning back in his
chair seat how each of these
high-school athletes measures
up against the heroic
individuals on that yardstick
championship team. Every gas
station attendant will be able
to decree as authoritatively
as the superintendent of schools
at what point the new coach's
back deserves to be patted
or his throat summarily slit.
On Monday morning, mayor
and minister alike will inform
their followers exactly why
this team will sputter or soar.
Every native wedged into
this sweaty brick building
has wagered his small-town
heritage on the outcome
of this season. The town
has lain dormant for many
a month; at the opening tip-
off it roars itself awake.

Somewhere in Southern Indiana

Somewhere in southern Indiana
a boy sits listening to a baseball game
on the radio. It is very quiet
in the house where his mother sits
darning socks and his father flips
through a seed catalogue. The dark
wooded hills surround the house,
which is far removed from the city lights
and baseball games. The only sounds
outside are the barking of a neighbor's dog
down the road and, occasionally,
the crunching of pick-up tires over rocks.

This boy who listens to the baseball
game never reads poetry, except when
he is required to for his English class.
He would not be interested in what
I write. He thinks poetry must be about
English knights and ladies in castles,
not boys who listen to baseball games,
mothers who darn socks, fathers who
look through seed catalogues.

One day the boy will move away
from southern Indiana to a big city,
where he will go to fine restaurants
and concerts and plays and begin to
read poetry on his own. He will feel
something stir within, and he will go
to the library, browse through magazines
in the periodicals room, pull off volumes
of poems from the stacks, and take them
home to his apartment. He will feel
a thumping in his chest, take out a piece
of paper, and try to make a poem.

Every sentence he begins will pull
him back to a scene in which a boy

sits listening to a baseball game
on the radio, a mother sits darning
socks, a father sits flipping though
a seed catalogue. The longer the young
man listens to the thumping within,
the louder he will hear the barking
of a dog and the crunching
of pick-up tires over rocks.

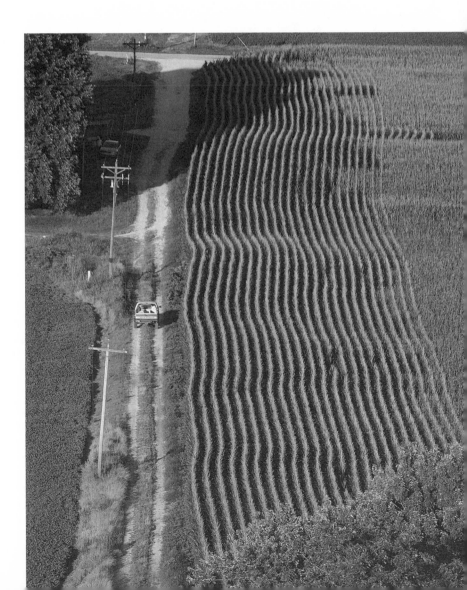

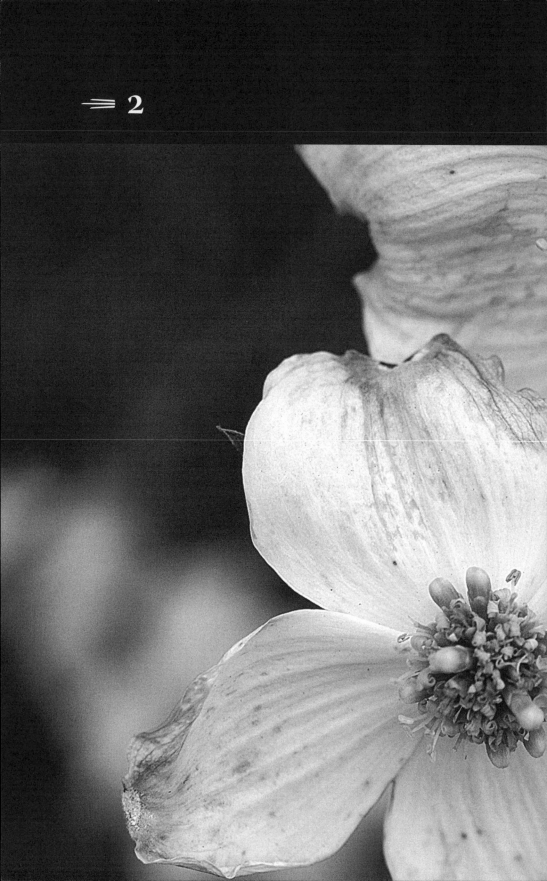

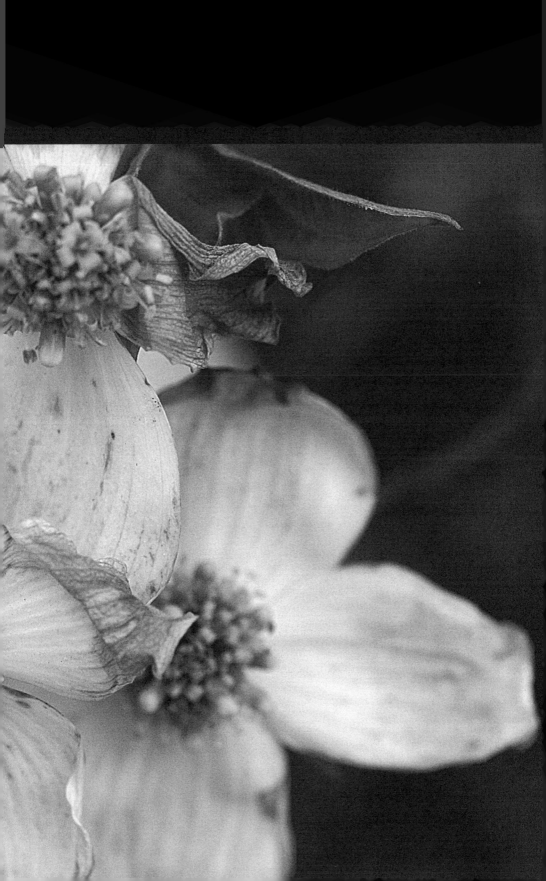

Arriving on Paumanok

Paumanok: *"The island with its breast
long drawn out."*
—W.W., Brooklyn Standard

A Midwesterner, an inlander,
a lover of the interior,
arrives on Long Island. "Paumanok!"
he whispers, savoring his Whitman,
local aborigine. "Paumanok," he says,
half aloud. He feels salt water swaying
on every side of him. He looks around
for the rows and rows of ripening
corn he'd sighted down since he was
pushed from the womb. None. Expressways.

"Paumanok," he repeats, looking
at a map. "Manhasset . . . Mineola . . . Massapequa,"
he reads. He picks out the red and green lines
looping the long breast. He turns them
on his tongue like strange herbs.
"Cutchogue . . . Patchogue . . . Ponquogue,"
he intones. "Wantagh and Wickapogue."

He feels a mist drifting in from the shore.
"Quogue and Nissequogue, Nesconsett
and Amagansett," he sings. He hears
the surf splashing nearer. "Commack
and Speonk and Setauket," he chants,
"Ronkonkoma, Ronkonkoma." "Shinnecock,
Peconic." In the middle of a fog
sliding inland off the sea like
the souls of the dead, he says, softly,
"Mattituck, Montauk." He whispers,
"Paumanok, Paumanok." He begins
to hear voices from the interior.

Sycamore on Main Street

It stands like a resolute
deserter of its own kind
high above frame houses
halfway up the hill.

Slowly, its brown mottled
bark has flaked away
leaving an ivory shaft
which glints in the sun.

Below the earth's surface,
its swollen roots crawl
homeward down the hillside,
wriggle beneath pipes
and pavement, plunge
into the depths, and suck
at the waters of the ancient
swamp beneath the park.

Ancestral Voices

Down the subway tunnels
of the family line
I hear muted voices
of relatives who were
buried back in Midwest
village cemeteries before
I was born. I see their
mustachioed German faces
paling in piety in oval photos
on Catholic memorial cards
my grandmother showed,
but remember their spirits
more fully fleshed in bawdy
stories my father told.
If their train could
somehow jump the tracks
between us, my ancestors
might pull up at this
New York station and cry
out the directions
which would light curves
in the long tunnel
leading up to myself.

Weeping Willow

Old World refugee
huddling around
lakes and streams

as if brooding
on what you left behind

with spineless limbs
and limp leaves

you crack the
first green whip
of spring.

Dogwood

Modesty keeps you
close to the earth

bark checkered
like the hide
of an alligator

purple branches
sometimes swollen
with swarms of insects

leaves bulbous
as an onion

yet you never
fail to rise
to the occasion

and flick tongues
of white flame
down village streets.

Gatsby Country

Here I float above Gatsby's Island
where the Mercedes and Jaguars cruise

boutiques multiply like mushrooms
and manna falls like acid rain

on acres of Gold Coast lawn.
Here I float tethered at the navel

to the hills of southern Indiana where
the sycamore stands by the muddy river,

the John Deere chugs between rows
of corn ripening in the valleys

and the turtle dove cries from
the heart of the pine at dusk.

The Roslyn Forge

In a corner of the room where
Joseph Starkins bellowed his
eighteenth-century blacksmith's fire
I press my pen across yellow paper.

Son of Indiana Schmitts,
old country *Schmieds* who became
new world farmers, I forge
my rough Midwestern lines

in a blacksmith shop
merchant Jacob Kirby converted
into an 1850 tenant house.
Son of Indiana Krapfs,

Franconian day laborers and weavers,
I settle my weight on the bowed
oak floor nailed fast to hand-hewn
joists on a Long Island plot.

New arrival in this old house,
I sit at my walnut desk
with Emerson, Thoreau, Hawthorne,
Melville and Whitman squatting

on common pine shelves. As
pipes clank and radiators steam,
I hold my pen tight as a tool
and feel the fire burn again.

Song of the Music Stand

Hand crafted
of rough-grained
dark oak as one
of a dozen designed
and built with crude
tools as a gift
in the winter of 1920

by the quiet,
moustachioed man
whose sawmill ripped
for free the timber
for the new village church
a few years before

the long octagonal
shaft rising
like a sapling
from curved feet
fitted like roots

into the slatted
limbs upon which
sheets of church music
rested for fifty-five
years in the choir loft

before it was
bought by a grandson
home for the holidays
from an old priest
for twenty-five dollars
which had to be borrowed
from the son who'd
helped to saw and sand
during that Indiana winter

stripped of varnish
gone cloudy and sticky,
refinished, dark grain
cutting through again
it stands in the corner
of a living room
on Long Island
bearing the quiet,
rough-grained poems
of the grandson

who sings this song
of the spirit
of the man
whose lips played
the trumpet,
whose son played
the violin,
whose hands
joined together
worked this wood.

A Midwestern Story

after Sherwood Anderson

The first snow of the year
falls on Main Street, Roslyn.
Big flakes settle upon
cedar shingles on the house
next door, the stone wall
in the side yard, the English
ivy in the rock garden.

I walk to the stove,
peer through a window
into the wooded hillside
where a brush pile blurs
into whiteness, and flash
back to the snows of my
southern Indiana childhood.

I remember the Midwestern
story of an old woman who
died in the woods. A pack
of hounds still circles
the tree against which
the immigrant woman rests
with groceries strapped
to her back. As she breathes
slower and slower, dreaming
of the wayward husband and son
who emerge from her farmhouse,
put a hand on her shoulder,
and whisper thanks, the dogs
come nearer, rush forward
to sniff at her back, and resume
circling in moon-white woods.
As the woods fill up with snow
the woman's body turns whiter
and younger. Eventually

a rabbit hunter steps forth
from behind a brush pile
and finds the beautiful,
naked body of a girl
lying untouched in the snow.

As I gaze through
the window fogging over
from my breath, I see
my mother standing at
the stove in a house
in southern Indiana woods.

She daydreams of her mother,
recently dead at ninety-four,
and the twenty-nine grandchildren
and sixty-one great-grandchildren.
I see snow falling
on a fresh grave
in a moonlit village cemetery.

I hear a dog bark
across Main Street, squint
back at the white woods,
pause, and feel these
words form on my lips:
Blessed are the dead
the snow snows upon.

A Dream of Plum Blossoms

for James Wright

My back to the traffic,
I stand on the sidewalk
reading the last poems
of an American poet
who loved the small things
of Italy with such quiet
intensity they brought him
home to the pitted banks
of a darkening Ohio River.

I lower the book and see,
at my feet, Adam Schmitt's
vacant lot on East 15th
Street in Jasper, Indiana.
I run across the grass
baseball diamond toward
the row of plum trees
in foul territory along
the third base line. As car
lights flash in my eyes
in night as black as coal
gouged up out of Pike County
strip mines, I come into
the presence of star-
splash plum blossoms.

They are everywhere; they
are dazzling. I have not
seen plum blossoms up close
for thirty years and am not
sure if these are real;
but so help me God,
in the center of each cluster
of radiant blossoms glows

a stamen as gold as the flame
at the end of a single
candle in a dark church.

The sweetness of plum
juice from an earlier day
still on my tongue, I stretch
to pick the lowest blossom
for someone I love when
I hear the shuffle
of small feet on the carpet.

I look down from my bed
in darkness and see my
daughter, three, curl up
on the carpet like a petal.

With a moist palm
I lead her back to her
bedroom above Main Street.
All-night traffic swirls
past like the rising
waters of a flooding river.
I close the windows.

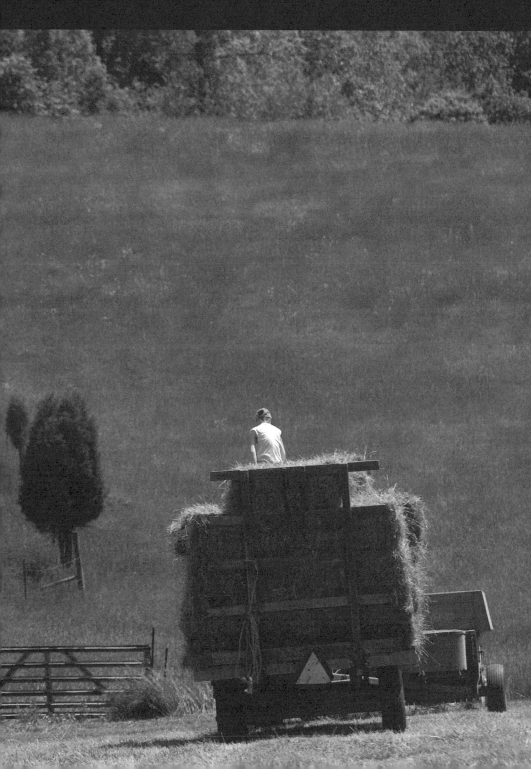
From *The Country I Come From* (2002)

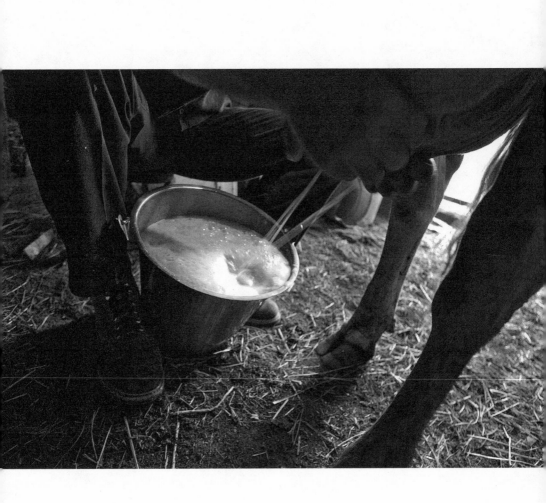

A Whiff of Fresh Sheets

Reading in warm June sun
a Kiowa's poems about
the spirit of a mythic bear
who lives and looms
in memory and imagination

when a breeze from the south
blows up a whiff reminiscent
of fresh white sheets dried
and bleached in the sun
on my mother's clothesline
in southern Indiana
almost fifty years ago

and I am carried back
a thousand miles by this breeze
and that fresh scent still
lodged in my nostrils

though she is gone
to the world of spirit
and the house we built
at the edge of the woods
has passed out of our hands

and I am there again
sent with a basket
to gather the wash
and I bury my face
in the white folds
of those fresh sheets
and inhale as deeply
as one can draw air
and the scent of the sun
into his lungs

and the taste and smell
of sun and fresh air

in the folds of those sheets
fill and lift and transport me

and I return decades older
to the page where the tracks
of the bear cross the page
in June sun and fresh breezes
blow across the German lupine
and columbine in my garden.

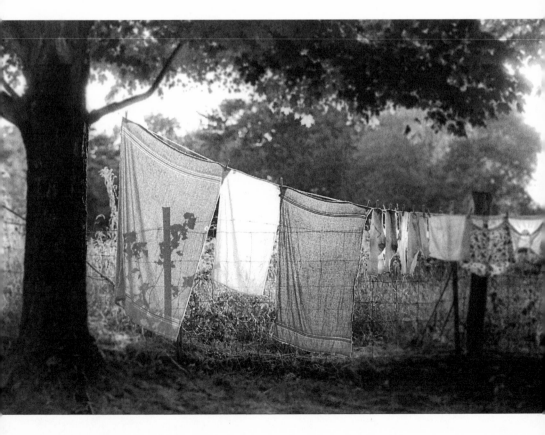

Full Circle

To wind up the hills
from Louisville, the Ohio
River bending at your back,
is to enter southern Indiana
once again and see out
of the corner of your eye
the red-tail hawk soar in its
eternal circle over the valley
split right down the middle
by the meandering creek
on the banks of which
the ivory sycamore prevails

is to notice dark-green
cedars appear on either side
of the sloping interstate
like shy friends from childhood
you thought you had forgotten

is to come into the presence
of the delicate rust
of prairie grass rippling
and rolling in the breeze
as a cottontail bounds
up the hill toward the horizon
beyond which some part of you
that has lain dormant knows
every angle and every grade
of every curve and awakens
and tugs and pulls you home.

The Language of Place

You have no name for it
but feel it pull on you
when you enter the hills,
like a forgotten language
a part of you spoke
thousands of years ago.

By studying you cannot
recover what has been lost,
but must let it rise
up from the landscape
and allow it to speak
in that part of the ear
that never unlearned
how to listen to what
is deepest as you give
yourself to the pull
of the place.

The way a creek bed
meanders through a hollow,
a breeze scrapes dry corn
leaves against one another,
a mulberry tree stands
at the bottom of a well
of sunlight on a hill
beside a sagging barn
built on a site where
hunters once camped
as they traveled along
the ridges the glacier left

may give off syllables
that gather into words
that build into sentences
that carry a meaning
you intuit but could
not translate for others

unless you feel the ancient
rhythm and ritual of prayer
suddenly rise up from
the ground and pass
through and beyond you.

The Language of Species

You want to make
a convincing statement
but all you can see
is the outline of a forest.

Wait. Don't speak. Move in.
Stand there as long as it
takes for the dark to lift
from your shoulders and light
to flicker on your forehead.

Look up. Watch a single tree
take shape and rise. Allow
the bark of the trunk time
to declare its texture.
Watch a leaf push forth
as a pattern. Listen to breezes
wash through the boughs.
Follow cuttings as they sprinkle
down through layers of leaves.
Trace the stream back to the source:
hungry fox squirrel or blackbird.

Now say what you see.
Say shagbark hickory.
Say pig hickory or walnut.
Say beech or black gum.
Say white or red oak.

When you can speak
the language of the species
others may listen and believe.

What We Lost in Southern Indiana

In 1800 swollen streams & the Buffalo Trace
ran through forests almost impenetrable.
Here & there, marshes. Birds that love a forest
& those that love water found a home.

The wild turkey was so plentiful we sometimes
shot it from our cabin door. You could kill
a dozen in a day & exchange them for salt
at Vincennes. Squirrels were so thick we shot

them to save our few fields of ripening corn.
The Carolina paraquet, long since disappeared,
we found in large flocks in low land around
Duck & Buffalo Pond. The Piankishaw used

their red, green & yellow feathers as ornaments.
Wild pigeons flocked by in clouds that darkened
the sky. People brought torches to their roosts
& waged war on the blinded birds with clubs & guns.

Hundreds were killed that nobody could use.
Red deer cut paths across divides in the hills,
& to springs & "licks" in the valleys. Once
the deputy clerk of Dubois County shot two

deer from his office window as they ran down
Main Street, Jasper. When we killed a deer
in those days, we took only the skin and the ham.
The women cooked venison & turkey by hanging

it beneath a slab of bear meat dripping grease.
Bears were abundant, & left the imprint of their
powerful claws on the barks of huge trees. Deep
in the woods we would find bear wallows clawed

out of the soft floor of a cave. Wild hogs roamed
the woods in such great numbers they were a threat
to human life. At Halls Creek Bottom, where they fed
on mast & roots, a settler once lost his life to their

viciousness. Wild hogs were so common we waited
until they grew fat & took as many as we wanted.
No one seemed to care. The wolf was a terrible menace.
Wolves under two months brought a dollar; those older,

two. To claim this bounty, a hunter had to produce
the wolf scalp & both ears. Hunters would find
a den, catch the puppies, make them cry,
& shoot the mother as she came running home.

The Buffalo Trace

Before European metal wedged
 into native poplar, before wagons
 rolled up from Kentucky, bison

would loll in herds in Indian
 summer sun chomping sweet
 grass on the prairie to the west

until their stomachs expanded
 and tongues longed
 to lick a coarser substance.

They turned in unison from
 the setting sun, splashed across
 the Wabash River and plunged

headfirst into the forest where
 maple leaves flared red and their
 hooves pounded hickory nuts

that rattled to the ground. Twisting
 and turning into the depths
 of the forest like a great storm

that leaves a clearing in its wake,
 they spiraled southeast, churned
 across the White River, drummed up

the hillsides and along the ridges,
 stampeded downhill through the valleys
 until heading into the rising sun they

slowed down, sank to their knees
 in the Ohio, floated like shaggy ships
 across to Kentucky, and coasted

to Big Bone and Blue Licks in bluegrass
 country. There in a sea of brown fur they
 scraped pink tongues across white salt

in the springs and heaved against
one another in the winter swamp until
they sank down pressed beneath the hooves

of those that came after them year by year,
bones packed in layers like stones in pave-
ment that cannot be lifted from their beds.

What the Miami Call Themselves

When they lived
in what we name
Wisconsin and Michigan,
before they moved
southeast to what we
now know as Indiana,
the Ojibwa called
them *Oumameg,*
"people of the peninsula."

Their closest allies,
the Delaware,
the Lenape,
called them
We-mi-a-mik,
Wemiamick,
"all friends" or "beavers."

The French, who
married their daughters,
referred to them
as *Oumiamiouek*
or *Oumiamiack*
and *Monami,*
"my friend."

The English, ever
in love with
their own tongue,
called them
Twightees,
"the cry of the crane."

In the *Me-ah-me*
or *Meame* tongue,
meeneea or *meearme*
means "pigeon."

They call themselves
Wa-ya-ta-no-ke
or *Me-a-me-a-ga,*
"nation born from
eddying water."
When they came southeast
to the Indiana Territory
they settled in the town
of *Kekionga,* "blackberry
patch," on the Maumee,

and gravitated toward
the eddying waters
of creeks and rivers we call
Wabash and Wea and Eel
and the swift Mississenewa
which carved caves we know
as their sacred Seven Pillars
before joining forces
and becoming one
with the Wabash,

Wah-bah-shi-ki,
Wah-bah-shay-ke,
Wah-sah-shay-ke,
Wa-ba-ci-ki
or *Waubache,*

"White or pure bright water,"
"water flowing over white stones,"
"white path," or "white like
the inside of a mussel shell."

Song of the Mississinewa

Na-ma-tei-sin-wi,
Na-ma-chis-sin-wa,
Mas-pis-sin-e-way,
the Miami called it,
"much fall in the water,"
"falling water," or
"it slopes and slants."

Villages that stood
along the water way
that sings and falls
and rises and bends
were *Washashie,*
Meskingomeshia,
Metosanya.

Mis-sis-sin-e-way,
we who came later
from far away
have said and spelled it,
Massassinawa,
Mississinway,
Mississineway.

See its waters flow
and fall and foam
and you will fall
in love with its
shape and rhythms.

Say it and you will
know what it means
to sing a song
hear a music
feel a spirit
that can never
be taken away:

Mississinewa.

Mississinewa River Lament

1

At dusk, white Queen Anne's lace
and goldenrod guard the gravel
parking lot. The shallow woods
are silent except for the bump
and buzz of mosquitoes. Between
the trees, two monuments, one
to soldiers, one to the Miamis,
and a dozen tombstones glowing
white on a knoll: twelve carved
names of soldiers who died (but are
not buried) here in 1812. Not one
piece of stone, not a single name,
to honor the Miami women
and children who died here
in their village. Not far away,
below a stand of ancient sycamore,
the river with the sibilant name,
source of secrets, still sings
its soft syllables of lament.
White shoals, luminous, break
over limestone shelves at dusk.

2

Next morning I return, haunted,
in broad daylight. Queen Anne's
lace, tall thistle in purple bloom,
white morning glory twining
stalks of thistle, blue chicory,
and goldenrod. Mosquitoes
remain the only visitors.

In the woods, many locusts,
long spikes climbing their trunks.
Slippery elm, cottonwood.

The liquid Mississinewa looks
even more dazzling in daylight.
I walk down to water's edge,
stand on limestone shelves,
see boulders stretching across
to the other side downstream.
What was it like to leapfrog
from one to another? What
was it like to live here in a village
so carefully situated?

I think of a bitter December
day when old men, women,
and children gather around
a fire to talk and do chores.
In their daydreams, it is summer.
Old men fish in the shoals; women,
singing, gather herbs in the woods;
children play games on the bank.
Corn, squash, and beans grow
in a field beyond the knoll.

Suddenly it is again cruel winter,
the insides of my nostrils freeze,
and I hear the crack of rifles,
the cries of children, the clomp
of hooves on brittle earth.
The smell of smoke hangs
in arctic air, rolls out over
a choppy Mississinewa.

What was it like to return
home from the hunt to find
your village smoldering in ashes,
women and children slaughtered,
corpses where crops had been?

Who or what twisted a language
capable of carrying the truth
home to the heart with such
beauty, grace, and power as to call
this "The Battle of the Mississinewa"?

Mississinewa Cottonwood Leaf

Along the river
of five syllables
I pick this heart
from a branch
of a tree rooted
in a holy place
and press it
in a notebook.

When I return
one year later
to reopen the pages
and revisit the scene
where Miami and Delaware
gave their lives
to save a village

I admire the saw-like teeth
edging the green heart
and the *S*-curve, bending
like a river, of its delicate
stem which I lift up
and spindle in the air.

When the heart cracks
in the middle and crumbles
into my hand I hear liquid
syllables speak again within
white shoals near those woods

and know I must
compose this song
to carry the spirits
of the past
into the present
so they can flow
toward the future.

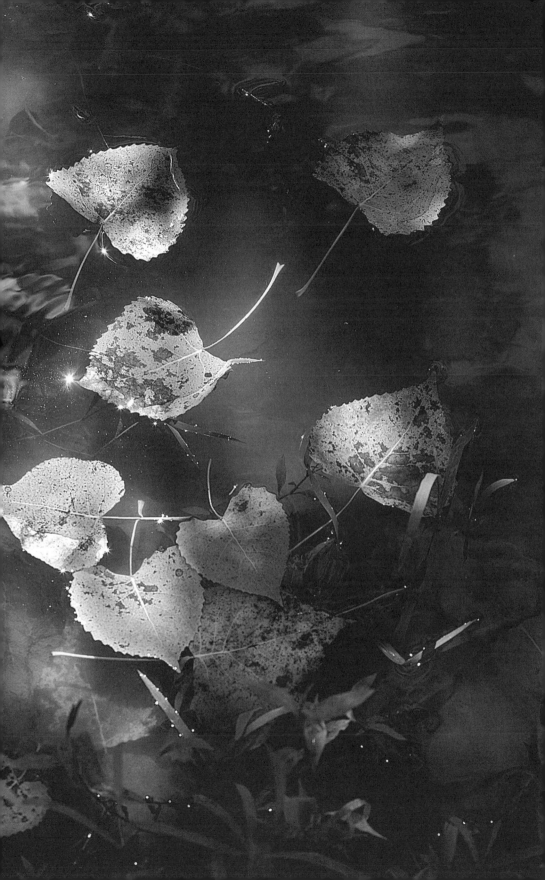

Lines Heard in Northern Indiana Cornfields

Be glad for moisture
hanging above
and beaded below,
for the color gray
in the sky,
for flat land where
corn and soybean touch
and stretch to a copse
of spectral trees
on the horizon.

Watch for the sway
of Queen Anne's lace
in early breeze
and the surprise
of backlit morning glory
twining around weed
and stalk of corn.

Acknowledge the blessing
of chicory blue
and soybean green.

Pause before a single
sunflower that took
a bright stand
a stone's throw
into a splash
of weeds.

Listen to what does
not seem to speak.

Keep an eye open
for what is thought
not to blossom.

Appreciate shades
of color that
do not flash.

Inhale air that
does not aim
to uplift because
all is level
unto the horizon.

Carry the plenitude
of plainness
with a bounce
of joy.

Give thanks
for the wealth
of the ordinary
rolling in from
cloudy gray across
prairie green.

May Apple

for Rose Marie and John Groppe

Walking down an abandoned road
toward a boarded-up brick house,
once a home for Indian children,
I look up in the Sunday morning
hush and see May apple green
whirling and rolling toward
the edge of the woods where
shopping center asphalt begins.

I kneel down at the side
of the road to peer beneath
this low canopy of green
and find a creamy flower
with a center as golden
as fresh butter holding what
light seems left in the world.

From a nearby stalk hangs
a tiny green apple that
has already passed through
flowering and come to rest
poised as ripe fruit.

At the base of stalks
coming up out of the ground
in every direction violets
beam their modest blue.

Whorls of green spikes
for which my tongue
can not shape the praise
of a name slant toward
the pull of light and poke
through slits in the canopy.

A thatch of dead brown leaves
on the ground grows luminous.

I rise back to my feet
quivering with thanks
for the gift my legs
have brought to my eyes.

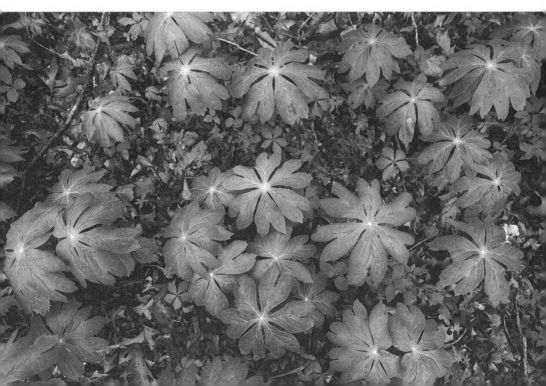

Fire and Ice

Dead of winter: snow, ice,
winds lashing the plains
of frozen northern Indiana.

The brick fieldhouse
of the Catholic college
that admitted only men roared
like an overheated furnace.

Poles, Irish, and Italians
from the cities around
the Great Lakes, a few
Germans from the hills
to the south along the Ohio,
we stretched our vocal chords
to the snapping point as
our team scratched, slipped,
rallied and finally failed
against Lutheran archrivals.

When we entered the igloo
of our freshman dorm
someone, incensed, found
rays of light escaping
into the hall from beneath
Leland Richard's door.

Leland was a black intellectual
from Cleveland who had dared
to stay home and not support
the holy communal cause.

Maybe he was reading a book,
writing a letter to his family
or just wanted to be alone.
Maybe he was thinking about
what to do with his life.

Someone knocked on the door.
No answer. Someone pounded.
Still no answer. "Stayed
in his room during the game!"
echoed down the hall. Someone
brought a can of lighter
fluid and squirted it under
the door. Someone else struck
and flipped a match. Flame
zigzagged under the door that
bitterly cold night as someone
chanted "Spear chucker!"

I stood there watching,
listening from a distance
while my friend sat alone
trapped between fire and ice.
I could not find whatever
words should have come out.

Leland never once mentioned
that night when we later sat
in the cafeteria discussing
literature and foreign films.
I could never bring myself
to ask how it felt to watch
flame shoot beneath his door,
hear the chant from beyond.

Two springs later after green
flames lit brown grass around
the pond in front of the chapel
with the postcard twin towers,
Leland entered a seminary.
I never heard from him again.
I have just learned he is dead.

One Voice from Many

*Written for the 100th Commencement
of St. Joseph's College, Rensselaer, Indiana
7 May 1995*

1

To come here from the hills
of the south to these plains
of the north was to bring
with you the voices
of those who came before
even though you did not
know they spoke within you.

For to learn how to read
the world opening before you
like the pages of a book
that you must translate from
more languages than one
is to learn to hear
the nuances of pitch
the beat of accent
and the turn of idiom
of the various voices
others help us to detect
as we grow toward
the single voice
integrated from the many
who came before and shape
the sound of what we say
as we discover the feel
of what we believe
on the way toward finding
who we shall become
and the mission of what
we must do to leave

something to hear, see,
and feel for those who
shall come after us
and become a part
of what we are.

2

When he came north
from the hills to the flat
cornfields where fierce
winter winds howl
as he had never heard
wind howl before, he did
not follow anyone in his
family to a degree or hear
any voice speak from within
his past to make him think
he might find a language
to speak beyond himself.

He came as the son of a father
who wept when he had to stop
school after eight and one half
years but could read and speak
German. He came as the son
of a mother named Schmitt
who finished high school early
after fooling a jealous big sister
by hiding high in the branches
of a maple in front of the farmhouse
to read James Whitcomb Riley,
but could not afford college.

He saw no poetry books
on the shelves of their house
and heard no poets talking
to one another across the ages,
to friends and family in his
hometown, or to himself.

When he came here he followed
others from the hills to the south
with unliterary names like Brosmer,
Gutgsell, Hoffman, Hollinden, Krodell,
Pfeffer and Roos. He came with buddies
named Backer, Betz, Eckerle and Spindler
who also missed the curves of hills.

He looked around and found classmates
from Chicago, Cleveland, and Cincinnati
who told him their families' stories at night
in the dorm: Herbst, Hattemer, Koenig,
Kuemmerle, Muth, Reichert and Schultz.
Putting their names together he did not
hear the smooth music of the poems
he began to read in textbooks,
but a collision of consonants
and the kick of a beat he felt
pound right beneath his ribs.

He looked up to new instructors
named Groppe, Herzing and Rank
who loved the ways of words
and helped him hear how they
whispered together and built
to a crescendo. He studied
under priest-professors Druhman,
Esser, Gerlach, Kramer, Kuhns
and Lang who put his fingertips
on the pulse of the past.

He stacked a semester of German
atop an overload, under a priest
named Hiller who corrected his
pronunciation of words he voiced
as he had overheard them said
at the supper table, in the streets
of Jasper and across the fields
of Dubois County. Reciting
the language of his ancestors

he sometimes heard a murmur
that seemed to rise up from
and through those who had
come and gone before him.

3

He remembers lying in the green
grass of his freshman spring
in front of campus buildings
as fresh breezes blew by
reading the Russian Dostoevski
in the grip of a fever that
has never released its hold.

He remembers standing transfixed
in the hall of a brick building
since burned to the ground
as a shaft of sunlight found
the page he was reading
of a long poem by Walt Whitman
of Long Island which included
no German names in his catalogues
of ordinary Americans and his
litanies of their everyday activities.

He remembers discovering
the passion and power
of the written word
as passport to a world beyond
wooded hills and cornfield plains.

But he did not write the word
except in letters to friends,
a few stories and poems
he hid in a drawer, and journal
entries he kept to himself.

He had not found a voice
which could reach back
to include those who came before

and could not presume to speak
to or for anyone but himself
as he moved on and away.

4

To come back here today
from Walt Whitman's island
extending east of Manhattan
to celebrate your going forth
as you stand where I stood
thirty years ago almost to the day

is to witness a new present
in the act of being born
and to speak in a voice
layered with the memory
of what has gone before

is to say that the past
you shall discover
in the process of going
where you must go
in building the present
that will shape a future

is to see that you
shall become a part
of those who will
come here after us
and discover that
our pitch, our accent,
our very idiom

will be heard within
the communal voice
that shall one day speak
to the many who follow.

Pastoral Poetics

Beetles rolling balls of dung.
—*Walt Whitman*

Summer afternoons on the farm
where my mother grew up
I would walk down the rock road
barefoot with a cousin to bring
the cows home from pasture.

To have your feet in shape
meant the bottoms had become
so thick and tough you could
walk on almost anything
without feeling pain.

Even if your feet were in shape,
you had to be careful where
you walked after you turned
into the pasture because
of what you might step into
and what might then squish
up between your toes.

You had to look down
when you were about
to step, even as you
looked over the hill
for a herd of cows.

Once I looked down and saw
a black beetle rolling a ball
it had shaped from a rich
brown platter. I couldn't
believe any creature would
take the time to make
such an attractive shape
out of waste that had passed
through another creature

and have the patience to
roll it across a pasture
where two barefoot boys
were looking for cows.

Years later when I read
a long poem by Walt Whitman
I couldn't believe I had found
a poet who actually looked down
at the ground as he walked
across a pasture, saw a beetle
rolling a ball of dung, and knew
he must put both bug and dung
in a poem in which he dared
to insist that not an inch
or particle of himself or anyone
else was vile and that he kept
as delicate around the bowels
as around the head and heart.

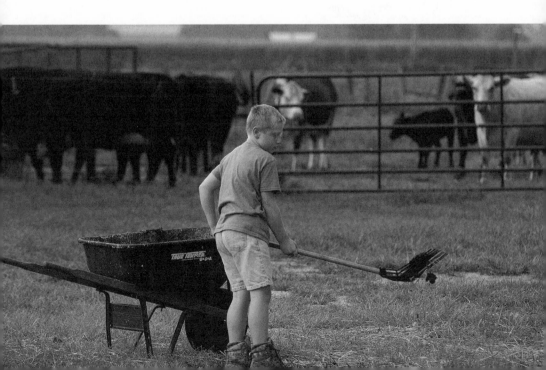

The Corn Cave

While others splashed
in the lake or sat
on the bank holding
poles with lines
at the ends of which
night crawlers wriggled
in the water

I slipped up the hill
and crawled into the shade
of a cave with a roof
of curved green blades
and beams of stalks.

As I sat cross-legged
between rows of corn
sunlight beat on my roof
and trickled through
onto my hands and face.

Streaked with light
I listened to cries
of cousins playing
and the low hum
of aunts and uncles
talking in chairs
beneath the walnut tree.

Corn silk grew
from ears ripening
above my head
as blades scraped
together and I
scratched the soil
between tall stalks
and picked at
the flinty fruit
of an arrowhead.

A campfire burned
where I sat in my cave
as food spiced
with herbs simmered
in clay pots

and I heard the call
in the old tongue
to come eat
at the long table

as cousins came
running and elders
stood and turned
to follow the young.

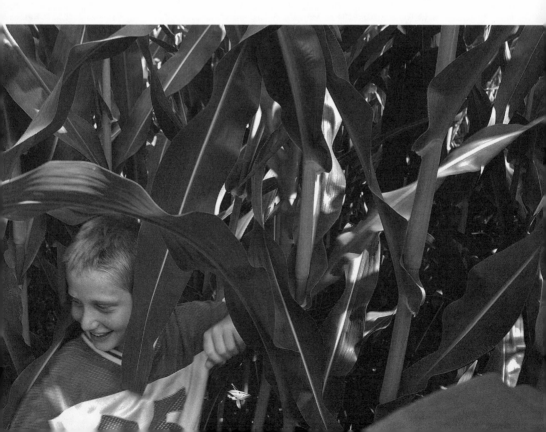

Hauling Hay

As the sun burned
on the back
of your neck

you grabbed a bale
with both hands
by the binder twine

heaved it high
enough to clear
the mounting stack
on the back
of the wagon
pulled along
by a tractor
groaning in low

someone stacked
it just right so
the whole load
somehow held
in balance

and the chaff
swirling in hot
air like a swarm
of sweat bees

settled on your
shoulder, slipped
beneath the collar
of your sweat-
sopped shirt

and pricked
the skin stretched
across your spine.

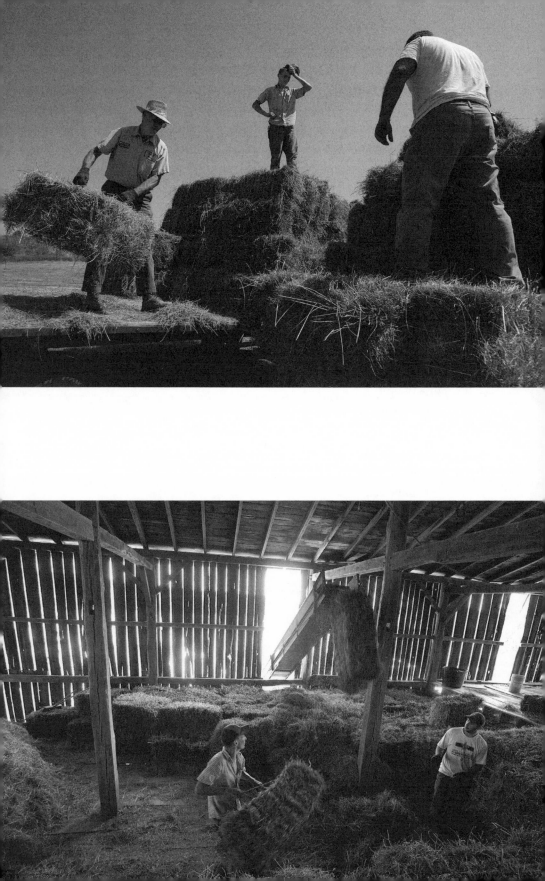

Hayloft

To grab hold of a rough rope
with both hands, push off

the edge of a stack of bales
with all your weight pulling

the line tight and swing free
feet first into the warm dark air

and land with a rich plop
on a bank of hay and roll

over on your back and look
up to see motes of dust canoeing

down a shaft of sunlight slanting
into the barn through an opening

where the elevator tip is propped
during the rush of hay-making

and to inhale the aroma
of sweet cow shit rising from

the stables below and turn over
on your side and draw your knees

up to your navel and rest
in the delicious quiet

of this warm place while
everyone is somewhere else.

Milk Music

Bows slurred across fiddle strings,
steel guitars twanged and whined,
and Hank Williams crooned
about a cheatin' heart.

Chewing her cud,
the cow looked away
as if pleasure were not
to be acknowledged.

Cousin Frank,
humming along,
squeezed her teats
with both hands.

Warm milk splashed
with a base beat
into the bucket.

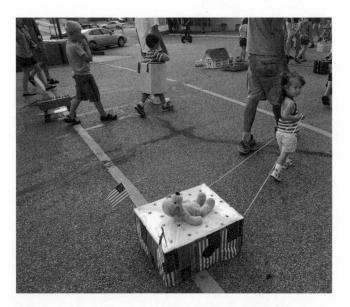

The Labor Day Boxes

At dusk we rolled
onto the sidewalks
pulling strings attached
to open shoe boxes
with crepe paper windows,
candle flames fluttering inside.

One year father made plywood
boxes with Tinkertoy wheels,
a hinged trapdoor, and sectioned
window frames covered with paper
patterned like stained glass.

Streaming together, we
pulled our votive flames
behind us into the dark
down the street toward
the factories where our fathers
made chairs and desks.

Like monks and nuns
in a diminutive order
we cried out a sing-
song incantation that
echoed back and forth
throughout the neighborhood,
Labor Day, Labor Day,

as rows of parents looking
down at the candlelight
rising to their faces gave
praise to our procession.

The Horseradish Man

after E.E. Cummings

Eddie and I
were playing
pitch & catch
in the vacant lot

& Susie & Sarah
were jumping rope
on the sidewalk

next to Mary Lou
& cousin Marlene
who were skipping
at hopscotch

& it was May

& old man Mehringer
was cutting his grass
with his push mower

& his Mrs. was
pinning up white wash
on the clothesline

when a man from
another neighborhood
rolled his Chevy
up to the curb

hobbled to the back
of the car
& opened his trunk.

We all stopped
what we were doing
& stared until
somebody yelled
from a front porch

"The horseradish man!"

Moms & dads
came rushing
from every direction
the Schroeders & Schucks
from Dewey Street

the Kieffners & Kreileins
from Vine

the Kleins & the Kueblers
from East 15th.

The line formed
at the trunk
& stretched
around the corner

& it was spring

& the gates
to horseradish heaven
had sprung wide open!

When the House Was New

There were no houses
in one direction but only
weeds shagging the field
sloping down a long hill
toward a road far below
and a ditch in the middle
with saplings on either side
and rabbits jumped ahead
of your step parting prairie
grass and quails kept sending
their semaphore of a song
from a corner of the woods
and the sun burned the back
of your neck a ruddy brown
and you could roam as far
as you wanted all day long
and the bottoms of your feet
were so tough you could
walk a straight line over
an eternity of rocks
and never flinch and across
the rock road in front
of the new house was a field
of rye which evening breezes
riffled and transformed
from light green to darker
blue and when the sun
started to sink on the other
side of the house a fire
lit up the sky and as you
toppled into bed you knew
you would roll over
and the morning would come
to meet you again as soon
as you opened your eyes.

Woods Hymn

Where the path crossed
on a log the creek
flowed after a rain.
Treetops shifted
and dripped
in the breeze.

I stood deep
in those woods,
eyes wide open
for the shapes
of leaves, ears
tuned to the cries
of birds and cuttings
of fox squirrels.

To look was
to affirm a faith
I felt particular
to the place.

To see was
to receive
a grace I could
not define.

To hear was
to know a music
that could not
be written down.

To breathe the air
of the woods was
to give thanks for
what was there
and nowhere else

and stood in need
of no thanks for
being what it was.

Bloodroot

I have seen
a light green
leaf, closely
coiled around
a stalk, emerge
through winter
brown leaves.

A flower rose
above, white
as fresh snow
atop a mountain.

Eight oval petals
opened like
parts of an eye
eager to behold
all that's new.

I dug and scratched
the rootstock
and saw a red
juice out of which
Potawatomi boiled
tea to bathe burns
and settlers squeezed
onto a lump of sugar
they held in the mouth
to cure sore throat.

White petals,
open again beneath
my eyelids.

Leathery leaves,
rub against
my fingertips.

Red potion,
cure this tongue
and move it
toward praise
of your powers.

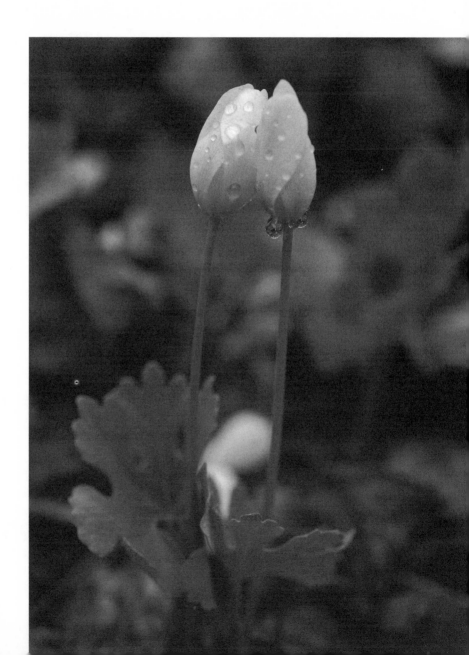

His Only Hickory Sapling

He was short,
he was quiet,
he was gentle,

but when he found
the only hickory sapling
on the hilltop property
he had just bought

chopped down by loggers
working in the woods
beyond our lot to clear
a lane to the rock road
in front of the site
where he would put
up a new house
for his family

my father rose
to a mighty
large-leafed anger.

He nailed a note
to a stake he pounded
into the ground
between white chips
they had scattered

calling them a rough
name I had never
heard come out
of his mouth.

As I later stood
on those white chips
shaping the sounds
of the words he had
slashed in black ink
on white paper

my father grew
taller than the largest
shagbark hickory
in the forest where
we hunted squirrels

and I felt how
deep his roots
turned and twisted
into the ground.

The Martin Box

Every spring when he
announced the time
was right we raised

and fastened the pole
atop of which stood
the tiered house

of many apartments
he had built of wood
and painted white

with green trim. We
waited for the first
purple martin to drop

onto the wrapped-
around porch and collect
bits of straw and cloth

for a nest in one
of the compartments.
Before long we would

hear the squeak
of the young
and the mother

would dive as
I cut the grass
with a power mower

and raise goose bumps
up and down the back
of my tanned neck.

But then they stopped
coming back and
the compartments

stayed empty and
quiet and my father
stood on the lawn

staring at the sky
in which hung
clouds of silence

and he walked away
with eyes dropped
to the ground.

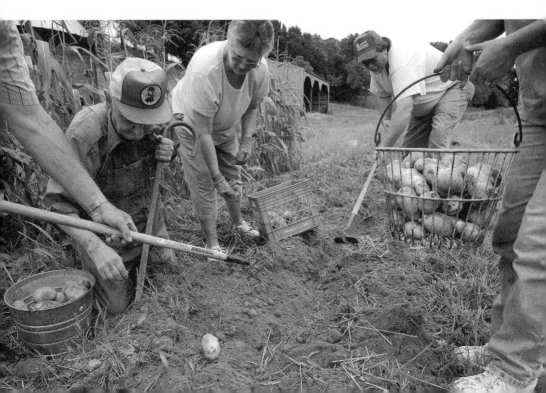

The Potato Barrows

Where trees once
stood and she
pulled out the stumps

he pushed the plow
along the mound
he had heaped.

I followed with
a bucket of cut
spuds I placed

eyes up at
intervals before
she came along

and folded the dark
earth at the edge
of the woods

back over them.
I watched green
stalks and leaves

push out into
sunlight and white
flowers open.

When the stalks
lost their green
and withered

she sent me with
a shovel and pail
to dig up enough

for a meal.
With the tip
of the tool

I pried loose
the underground fruit,
touched their tender

skin and later
broke into white
flesh with a fork

after she boiled
them on the stove.
Later after we

rolled them out
of their long
barrows with

the prongs of
the plow we
hauled them

in bushel baskets
in procession
into the basement.

We laid them
out on newspaper
for the winter

and came back
to find the survivors
sprouting eyes

in the dark,
as daylight expanded,
ready to be

quartered
and set back
in the ancestral

mounds to bloom
again at the edge
of the woods.

Gathering Hickory Nuts

After the first hard frost
we packed into the Chevy.
Father drove slowly along
a winding road, into the hills.
We squirmed in the back seat
as rocks kicked up against
the bottom of the car.

When we finally arrived
at the Blessinger farm
we coasted into a field
across the road from
the sloping woods and parked
beneath a black walnut tree.

Burlap bags slung across
our shoulders like wings,
we flushed from the car
like a covey of quail,
glided down the hill
between tall trees, and came
to alight beneath the first
shagbark hickory that had
splattered its hard fruit
on the frosted forest floor.

We stuffed our bags
with the hard white nuts
that emerge like pearls
when the brittle green husks
hit ground and split apart.

The deeper we drifted down
the hills, the heavier our harvest.
At the bottom of the hill where
woods opened into pasture
we turned, balanced our loads

on our shoulders and headed
back toward the car.

The darkness following us from
the pasture pressed against our
backs and pushed us up the hill
as we rushed to reach the far
field where light still flickered
and faded on the empty Chevy.

At the edge of the woods
Mother picked orange-eyed
bittersweet to stick in a jug
in a corner of the living room.

We surrendered our treasure
of nuts to the trunk and drifted
back down the hills in the dark
to the warmth of home
like an old ship provisioned
for a long hard voyage.

The Quilters

They took turns coming to one
another's houses in the winter,

my relatives and neighbors,
and I remember the long frame

from the farmhouse we stored
in the attic and would set up

in the living room we usually
kept closed off and unheated.

We pulled the curtains back
and opened the vents and they

sat facing one another, three
to a side, stitching and talking,

pausing only to roll the fabric
tight around one pole when

the stitching overtook the unquilted
space between them. They broke

for dinner at noon, moved to
the kitchen table where they

chewed, smiled and talked before
returning to the living room to stitch

and tell stories through the afternoon,
broke off at five for soup in the kitchen

where they sipped and klatsched,
then stitched and gossiped well

into the dark and it seemed every line
and space had been thoroughly stitched

and every story completely told and they
laughed and said goodbye and good night

and the house shrunk back into silence
after the last quilter went out

the back door. Later in my bed I saw
again the movements of the needles

and heard the tongues stitch together
their common quilt of memory.

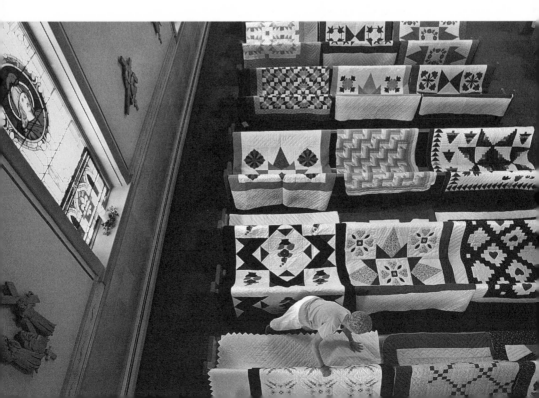

Saturday Night at the Calumet

When the band from Louisville
cranked up the rockabilly,
the girls sprang from their chairs
and danced onto the floor.

The guys stood back along
their tables and poured drinks
from bottles they had stashed
in their sport coat pockets.

The later it got, the stronger
the drinks, the longer the songs.
When the band lapsed into a slow one,
boys ventured onto the floor with girls.

Lights grew dimmer, smoke thicker,
and the hardwood floor pulsed
on piles above muddy lake water
as tempers flared toward the last dance.

When the band pulled their plugs,
lights flashed back on, and the lead
singer and his backups left
the hall with their first choices.

Someone always wanted to fight,
someone always got sick in the lot,
and two daredevils always played
chicken on the road back into town.

Because I Could Not Stop

after Emily Dickinson

It was well past midnight
after the Saturday night dance.
I had no idea where I was going,
or why, but could not stop
myself from taking a ride.

My father's car held only me.
No friend came along to drive,
but Someone sat at my side.

That car sped due south,
no destination in sight or mind,
along the only straight stretch
between the slumping hills.

I leaned toward the wheel
squinting ahead. All I could see,
in my boozy blur, was a needle
standing with its back pressed
up against a glowing 120.

Seems like eons ago the hood
of that car was aimed at infinity.

How or why I survived that
desperate drive long enough to
tell this foolish tale I have no clue.

I only know that somewhere—
between there and here—
I grabbed the pen, shifted
from gear to gear, and drove
deeper and deeper into the dark

before turning around to
head back toward the light.

Song for Bob Dylan

(1971)

The restless little
Midwestern creature
with reflecting eyes
tingling antennae
and scraping cry
secretes himself in
a new myth for each
winter and then drops
out and wings away
to another tree just
as his followers
begin to wriggle
in the cocoon
that's fallen behind

Odysseus in Indiana

Back in the hills again after
twenty years of wanderlust
on an island far to the east:
the home place is in bad shape.

The best squirrel-hunting woods
in the county stripped of giant
shagbark hickories and white oaks
by logging crews from somewhere else.

An asphalt parking lot stretching
toward infinity from shops in a mall
blackens the fields where my favorite
setters pointed coveys of quail.

Prefab houses arranged in rows
where my best rabbit traps tripped,
the river in which I caught sweet
catfish percolates like leftover

coffee heated by the chemicals
factories dump down its banks.
Basketball goals shorn of nets
tilt off center, ragged weeds grow

where I fielded hot grounders
and cracked hard line drives.
Lamentation and loss lie like
a blight across the land.

The fingerprints of old friends
run up and down both barrels
of my twelve gauge and the key
to the walnut gun case is gone.

In the corner of the bedroom
on the smooth oak floor I laid
sprawls a delicate nightgown
whose threads are unraveled.

In the taverns where they barely
recognize me because of the gray
streaking my beard and the tinge
of Eastern intonation in my voice

they tell me my old sweetheart
the cheerleader got tired of waiting
and left town with the all-state hotshot
from the burg across the valley.

Nettles grow all over my father's grave.
My mother sometimes forgets my name.
The old place was bulldozed and burned.
Nobody around to speak the old language.

I was a damned fool to come back.
You can go back home, all right,
but what you find there is always less
than what you thought you left behind.

Return to a Mighty Fortress

in memory of Jack London Leas

College kids home
for the vacation
in the small town
in the hills, we gather
in the house of our
mentor, Jack the Ripper.

Beer, Beethoven, more beer,
and then Bach: Toccata and Fugue
in D Minor rattles the front windows.

But to listen to E. Power
Biggs boom it out on a record
playing on a stereo in a living
room is not the same as hearing
the master played by someone
you know in a church built
of sandstone hauled from a farm
beside the banks of the Patoka River
by German-Catholic pioneers
whose names you inherited.

So we pile in Ripper's car
and lurch toward the Romanesque
fortress with the Tower of London
in the center of town, St. Joseph's
Church, where we were all
baptized and confirmed.

My musical friend who
several years later choked
off his life with a belt around
his neck has the key from
the old choirmaster, Professor
Loepker, and opens the doors
and the mighty console.

We sit in sudsy piety
where at Midnight Mass
every Christmas Eve
since early childhood we
have listened to the ethereal
tenor of Maury Gutgsell
sing "Stille Nacht"
and "Adeste Fidelis."

Jeff warms up with
"Tantum Ergo," plays
"Jesus, Joy of My Heart's
Desire." We applaud,
but know it's not enough.

Ripper, a late convert
to German Catholicism,
claims he hasn't touched
an organ in years, but we
know when the time is right
and prod him up the stairs
to the choir loft and beg
for that Protestant anthem
we Catholics covet,
"A Mighty Fortress Is Our God."

"Sacrilege!" Ripper chortles
as he hits the first key and brings
Martin Luther alive in the House
of Indiana German-Catholicism.

The pipes expand as he
builds to a mighty crescendo
and Catholic dust settles
on our heads and shoulders
as we rise to our feet
and applaud wildly
the musical wizardry
of the man who just
a few years before had
peered down at us from

his desk over reading glasses
to inform us exactly where
we should have put
the required comma
in the compound sentence.

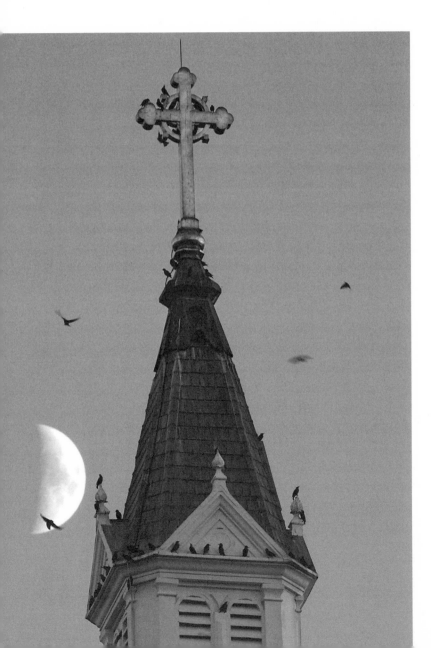

Song for a Sister

Back at the site of your tiny tomb,
sister, still not sure what to say.

First fact: Born Jan. 25, 1950.
Second fact: Died Jan. 25, 1950.
This year you would have turned 45.

They named you Marilyn,
but you may have been gone
by the time the name was given.
Or perhaps the name was selected
and waiting like a baptismal
gown sewn for you to fit into.

I don't know whether to say
you died in being born
or were already dead
before you could be born.

Let's just say your death
coincided with your birth
and that I never saw you.

I believe in you nonetheless.
Perhaps I miss you more
for never having met you.

Whenever I return from
the Island in the East
I come back to your small
stone on which it is carved:
GONE TO BE AN ANGEL.

Halcyon times, the time
of your birth and death,
the pundits tell us,
but I remember our mother's
grief all too well, the sound
of her sobs descending the stairs

from the bedroom in which
her mother scolded her hard.

Grandma's husband, you may know,
left her and this world at age thirty-three
with six young children on the farm.
No time for self-pity. Pigs to feed
and butcher. Meals to cook,
clothes to wash, crops to put in.

Our father swallowed his grief
over the loss of a daughter,
carried it for years.
It had to tear at his guts.

Marilyn, I have concluded
that in talking to you
I speak to that part of myself
I have not been lucky enough
to discover but which will one
day rejoin and complete me.

The green grass of summer
grows around your clean-carved,
well-trimmed tombstone
not far from the tall tomb
of the maternal ancestor
who came from Lohr am Main.

To return here
from far away
and try to preserve
even the slightest trace
of you is to pay
tribute to a life so dear
its mysterious end
arrived as it began.

The Dropped Pigskin

for Mick and Mary Ellen Stenftenagel

Broke through a big hole
in the line into the open
with nothing but long white
stripes and my first touchdown
coming toward me.

 Looked back
and found my best friend Mick
had laid a perfect spiral into the air
spinning toward me in slow motion.

Watched it smack my hands
and fall to the ground.

Had to turn and run back
to the huddle past the subs
and our young coach
from Western Kentucky
who spoke with a drawl
thicker than autumn mist
hovering in the hollows.

"Son!" he yelled in my ear,
his voice rising above the din
of the crowd like the bay
of a hound that's finally
treed an ornery coon
after chasing it across
the whole damn woods,
"you ever do that agin
I'm mo slit yore throat!"

He didn't have to.
Second half Mick
cranked it up again.

I broke open, he spun
the pigskin into the air,
I hauled it in and heaved
it underhanded into the air
as I jumped into the end zone
and came back to solid earth.

Coach stood on the sidelines,
cocked his Kentucky head
to the side, nodded, pounded
absolution with his palms.

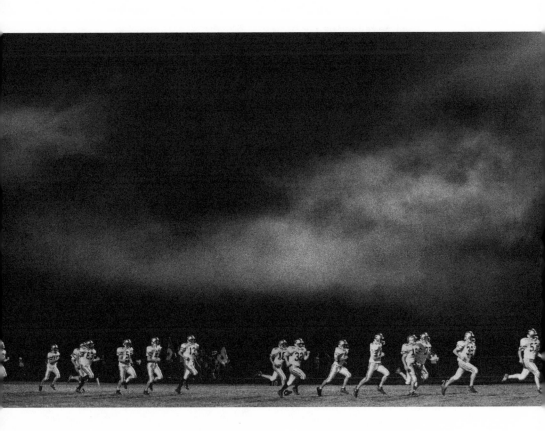

Dream of a Hanging Curve

When I see it spinning
like a Florida grapefruit
toward me, let me not
lunge at it like a rookie.

If it's outside, help me
shift my weight and lash
it to the opposite field.

If it should come down
the middle, let me send it
right back where it came
from, but harder and faster.

If it comes toward the inside corner,
give me the patience to wait,
turn on it, and pull it down
the line to kick up chalk
and carom around in the corner.

If I should have the luck
to make the right connection,
follow through perfectly
and see the ball rise
in an arc that will end
somewhere behind the fence,
let me not take too long
to circle the bases, gesture
toward the other dugout,
jump onto home plate,
or high-five everyone in sight
while the pitcher hangs his head.

If this dream comes true,
do not let me expect it
will ever happen again.

Do not let me change what
I have been doing that
got me to where I am.

Let me stay here as long
as I can give what I have
been given to contribute.

Let me be remembered
for what I became,
not for what I might
or should have been.

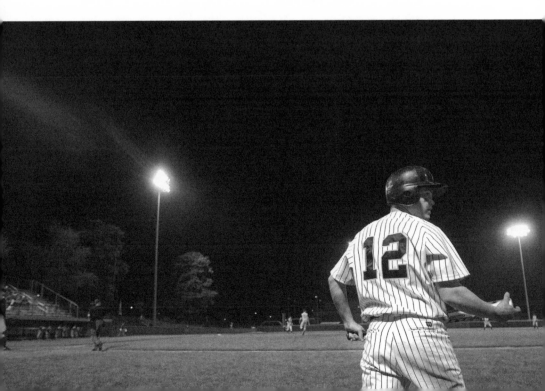

Dorothy and the Jewish Coat

Before Clara entered the convent
in Indiana she cleaned and cooked
for the Rosenfeld family in Louisville.

When Clara's brother-in-law Frank,
my grandfather, died young and left
Mary, my grandmother, with six young

children, Clara told the Rosenfelds
and they sent a care package of used
clothes to the farm in southern Indiana.

Dorothy, six, got a good coat
which kept her warm and almost
happy during that first hard winter.

One Sunday after mass Dorothy
stopped in town to visit her mother's
parents; and the uncles teased her

about her new old coat. "Oh I
would never wear that coat,"
one taunted. "Jews stink!"

Seventy-five years later my mother
tells me the story of how she cooked
and cleaned for two Jewish families

in Louisville after graduating from
high school and remembers, as if it
happened yesterday, how sharply

she felt the sting of an uncle's hate
whenever she wore the Jewish coat
that kept her warm in the winter.

The Mandolin and the Tenor

for Frank Schmitt

Winter nights when animal breath
hung frozen in the barn
you gathered wife and six
children around the wood stove
in the old farmhouse,

picked a delicate, haunting
tune on that most American
of instruments, the mandolin,

and lifted your tenor toward
the cold Indiana heavens
as you sang for the family
that most German love song
of loss, *Du, du liegst
mir im Herzen.**

I never heard your tenor,
Grandfather Frank, never saw
the mandolin kept in a closet
until it became a toy children
wore out, but the long-gone
instrument still resonates

as your daughter, eighty-three,
tells me again the story of your life
and sings for me your sad German
song in her most frail of voices.
In return, I sing this song
of her loss of a father when
you were thirty-six. She
was only six. Your oldest child,
my godfather, was only twelve.

*You're still in my heart.

I leave you singing *Stille Nacht,*
heilige Nacht in your heavenly
tenor in the choir loft of the village
church on Christmas Eve and repeat
as your epitaph this refrain:
Du, du liegst mir im Herzen.

Let Morning Light

After the hard winter night,
when north wind whipped
against this house, let morning
light come out of the east
and find its way to the kitchen
table where she sits, in clean
clothes, lifting oatmeal, slowly,
to her mouth with a spoon.

Let sips of coffee wake her
to the core and send heat
all the way to her nose
and tips of arthritic fingers.

Let her walk, step by step,
into the sunroom, pull open
the curtains, sit down
in a recliner, and watch the sun
rise higher and brighter as she
listens to local news on the radio.

Let her fall asleep in the chair,
if medication pulls her down,
and wake up when an old friend
calls to see how she feels,
or when it is time to sit down
at the table for the main meal.

After the dishes are washed, let her
settle down in the white-oak rocker
beside the southern window,
facing the woods, and bask
in the sunlight warming her face.
Let the branches of winter trees
cross in a pattern that pulls her
back to her childhood on the farm.

As the sun passes along behind
the house, turns the corner,

and reappears in the west,
let afternoon light intensify
through the window in her bedroom
and warm the covers on the bed
into which she may crawl for a nap.
Let the quilt whose patches
she cut out and sewed together
rise and fall as she breathes.

Let the dusk bound softly
toward the house, the dark
fall gently, and the night surround
the house but relent. Let the light
come out of the east again and find
her sitting in clean clothes at the table.

Hugging the Spirit

Odysseus followed Circe's advice,
sailed north into cold shadows,
offered warm blood to raise the spirits.

Thus he found his mother, who had died
while he wandered. He longed to hug her,
to hold her close, but could not reach her,

whom he loved so much, whose voice
spoke his name across the abyss. For even
when spirit is as close as the heartbeat

in your chest, you cannot reach out
and touch it. You must honor the distance,
even as you feel the pulse of the cord.

So I flew back home, Mother, and found you
in your reclining chair in the corner of the room
where morning light enters. You rose, shakily,

out of the shadows. I put my arms around
what I could find of you, held what was left
of your flesh, and kissed your thinning lips.

It was like kissing the mist in the valleys.
I saw faint light flicker in your sunken eyes.
I knew I could not hold you for long.

I had to let you return to the shadows.
I sat and watched you labor to breathe
with your eyes closed. I played a tape

I made of songs you loved, in the old tongue.
I saw your lips shape some of the words.
Once you voiced a line in a high register,

and almost smiled. I knew you were sailing
back to rejoin the father who died when
you were but a little girl. It was as clear

as the sunlight that you were ready to go.
I tried not to hold on too long, for I knew
that spirit cannot be contained in one world.

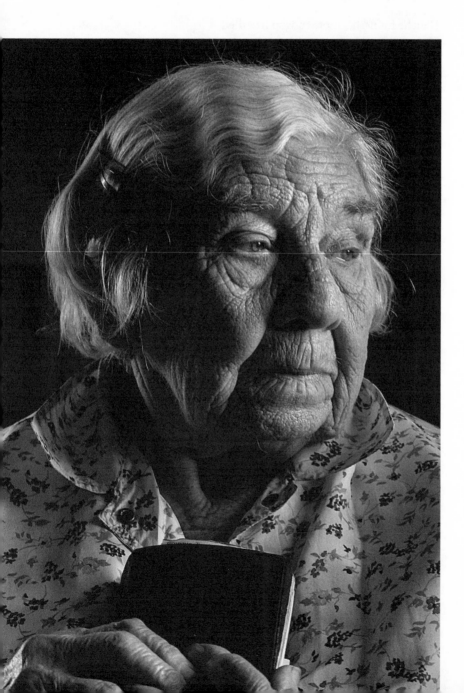

Farewell Lullaby

Lay your weary head,
poor sick mother,
on my shoulder.

Soon you shall rest.
Soon you shall hear
the mandolin music
you loved as a girl.

No, nothing you ever
said or did could cause
sickness and suffering
like what you endure.

Soon, soon you shall rest.
Soon these trials shall pass.

Soon the wrinkles
on your forehead and face
shall disappear like snow
when warm sun shines.

Soon the smile shall return
to your thinning lips like
the wildflowers that appear
each spring in the woods
where you played as a girl.

Soon you shall hear,
once again so clear,
the fatherly tenor
that slipped into silence
when you were so young.

Lay your weary head,
poor sick mother,
on this shoulder
as light from afar comes
to rest on your face.

At Least Now

At least now
she does not have to
try to catch her breath
swallow food hard
suck ice to wet
her parched throat
struggle to get out
one more word
on the phone.

At least now
she does not have to
worry about whether
the stove is still on
the bills are paid
or if there is enough
cash in her purse
or the back of the drawer
to buy more groceries.

At least now
she does not have to
be embarrassed about
the memory that crashed
and the hair that fell out
or care about the wrinkles
that wrapped around her face
or the flesh that vanished
from her bones.

At least now
she does not have to
fear the cold that found her
no matter how high
the furnace was set
or how close
the electric heater roared.

At least now
that she has graduated
to pure spirit she can
soar where she wants,
perch on our shoulders
and come along
wherever we go.

The Reunion

My father sits
hunched over
on a stone bench
as my mother's
shadow approaches.

He looks up
in surprise, says:
"Oh, I didn't know
you were coming!"

"It took me so long!"
she sighs. He moves
over to make room,
Mother settles down
beside him once more,

and they give
one another
the kind of airy
embrace spirits
offer when they
find themselves
together again
in the same world.

"Isn't that bird
song beautiful?" she
asks. "Yes," he
answers, "but it's
so different from
what we knew."

She tries to whistle
a reply to the song
she hears, but
the melody that floats
out of her mouth
is pure abstraction.

Places

Some of my ancestors were
hired hands in fields along a river;

others worked on boats
carrying cargo downstream.

I was born and grew up
inland in the hills.

I have lived as an adult
on a fish-shaped island

and I shall return
deep into woods

in which spirits rise
like spring water

and meander downhill
over sandstone.

From *Looking for God's Country* (2005)

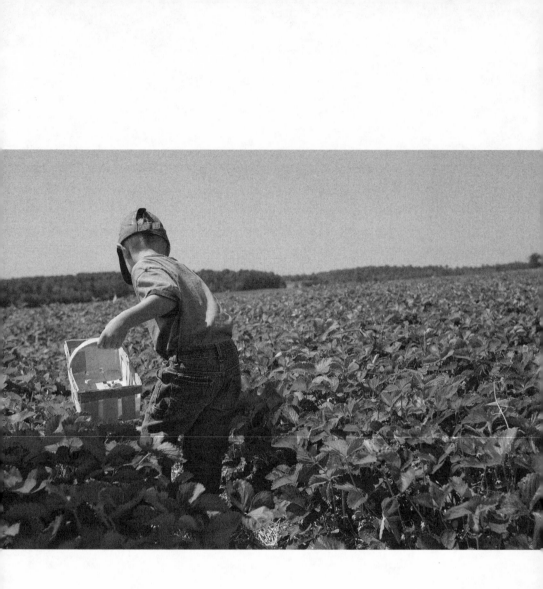

Letter from a Star above Southern Indiana

It was a crisp fall evening. The leaves were down, smoke was rising from neighborhood chimneys, and I was walking home, across an open field, from a Boy Scout meeting held at the parish school. Usually I keep my eyes on the ground, but on this clear night, as fresh air touched my cheeks, my eyes turned upwards, then soared above our new house at the edge of the woods. What I found in that southern Indiana sky was "miracle enough to stagger sextillions of infidels," as the great earth-poet Walt Whitman once said. There, burning bright above me, were so many dead stars I could never have begun to count them, if I had wanted to.

What I want to tell you now, wherever you are, whenever you read or hear this, however it is transmitted, is that even though I could not have framed the experience in just these words, even then I knew I was being blessed. Now, a thousand miles and almost fifty years away, I can tell you this: When I made out the shape of the Little Dipper, way above our house in that little woods in southern Indiana, I felt its collapsed light heading toward me, from thousands and millions of years away. When I also located the shape of the Big Dipper, so high above, I could feel its no-longer-alive radiance pouring down toward the house my parents had built for us children.

At that point, I had not yet seen or stepped inside the brick farmhouse that my father's family had built, with the help of new neighbors, when they arrived from Germany. Framed with tulip poplar from the virgin forest, it stood on a hill just inside the next county. I had not yet discovered that my mother's and father's families once lived about twenty miles apart, in the region of Bavaria known as Lower Franconia. Yet a part of me, the one that is finding these words to beam to you, understood on some level that the family who had crossed the Atlantic on a boat were walking with me under the stars, toward the house that

would later become a Long Island home for me, my wife, and our children. I could not yet name all those who came before me, but felt their presence at my side, knew they were guiding me wherever I would go. I knew I must learn to speak their language, which some of us had already left behind, but which mother and father still spoke.

All who came before were walking with me, toward the new house, as the light poured down on me from millions of light years before, just as I am walking with you, wherever you are, trying to speak to you in this language I hope is still yours, in this world I hope I still share with you. If you look up, as I looked up that night in southern Indiana, when the air was so fresh and clear, you may feel the light of this letter falling down toward you. You may even think you can see me in the night sky, will understand that I once walked the earth where you now walk. May this light bless you, your house, and those who come after you.

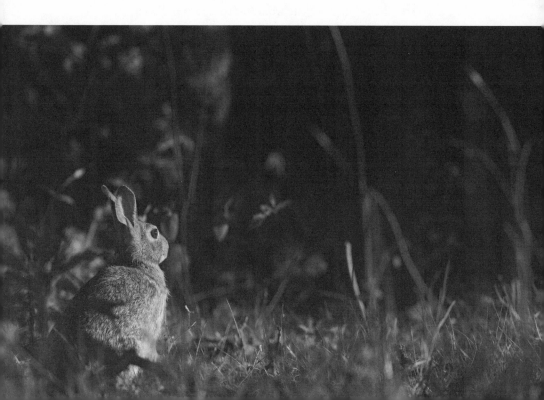

The Nest

At the edge of the woods near
where it comes close to a corner

of the house, between the moist
curves of ferns unfurling in brown

leaves, I found this tiny nest
in the ground. It was lined

with elements that looked to be
soft to the touch. This was right

near Easter. There was squiggly
movement in that lined hole

in the ground, what moved was
new-born rabbits, so tiny you could

barely tell what they were, and I tip-
toed as close as I dared. My mother

told me that if my smell came too close
the mother would abandon her babies.

I sensed that the difference between
loving and killing was eggshell thin,

but it was hard to control my impulse
to inch closer and closer. Reader,

I cannot be sure if I stayed far enough
away from what I longed to touch

but knew I must not. Is it shame that
blocks me from remembering the out-

come of this backyard tale? Let us join
hands and pray, in our different ways,

that we learn how to control our impulse
to love that which dies if we come too close.

Strawberry-Patch Song

Afternoon sun filled the room
in which I stood as a boy,

looking out the open window.
My mother was kneeling on stems

of yellow straw, picking red strawberries
in a blue sundress. As she piled her basket

with layers of ripe berries, the sunlight
coming through that western window

intensified, as if I were climbing
to a higher level of illumination

even though I did not know where
my feet were stepping. I heard her

sing a song that seemed to rise out
of the leafy green plants she was picking,

as much as out of her open mouth:
"I was dancing with my darling

to the Tennessee waltz." Whenever
I put a strawberry in my mouth,

break it open with my teeth, and taste
its watery sweetness with my tongue,

I feel the light streaming through
that western window again, see her

kneel between those rows of plants
sagging with berries, and hear her sing

that song as if it came from beyond
her and passed from me to you.

The Gardener

He moved through the garden,
on his afternoon off from selling

insurance, as if it were a preserve
in which he alone controlled

the cycle of birth and death. He knew
well his power and his responsibilities.

His father, though by then long dead,
moved with him at every step,

spoke in his ear when necessary.
He knew just how to sharpen a hoe

with a sandstone he spat onto before
applying it to a dulled edge. He knew

how to turn that hoe at the right angle,
to undercut and remove the weeds

that threatened peas, beans, squash, corn.
He knew how to heap the mounds

of dark earth in which potatoes sprouted
and swelled. He knew what powder to

put on which vegetable at just the right
point in the growing season to eliminate

the insects with the appetite to devour.
I can still see him standing there,

in old jeans and straw hat, lift
a red handkerchief from his back

pocket to wipe the sweat off his brow,
limp over to the next row and begin

to jab that hoe again at the right angle,
swing the big scythe back and forth,

around the edge of the garden, so the tall
weeds fell with a compliant swish.

At the end of the afternoon, my father
would clean and oil every tool, stack

them neatly in the shed he had put up
under the sugar maples, and stand

in the light of the setting sun and savor
the green order he had given the garden.

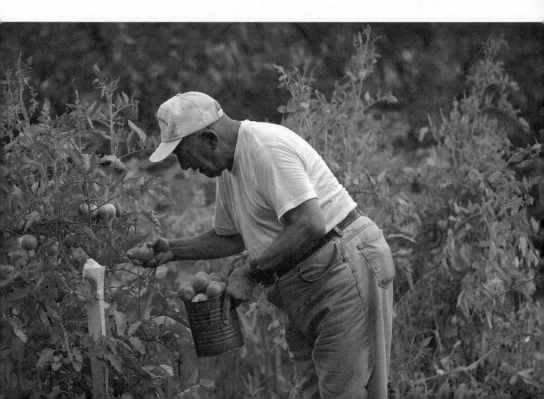

Chicken in the Woods

Back in the woods near the edge
of our property, Mother carried

a squawking white chicken, by the legs,
in one hand and a hatchet in the other.

She was still a farm girl. She stopped
at a stump, put the chicken's neck

on the flat rings of the amputated tree,
and whacked that chicken's head

clean off, then let go. Blood spurting
all over the leaves, the headless

chicken did a terrible dance of death,
flapped its wings, turned lopsided

circles until it finally came to rest
on its side in the leaves. After those

legs let go, Mother picked up the chicken
and dunked it in scalding hot water.

She plucked the feathers off with deft
fingers, cut the carcass right open,

saved what needed to be saved,
got rid of what could not be used,

and walked back into the house
ready to do her next chore. I saw

splattered blood on those leaves,
even after a good rain rinsed them off.

Godfather's Fishing Knife

in memory of Alfred Schmitt

I open the fishing knife
I inherited when he died,
slide my fingertip along the blade
and flash back to the fishing camp
he shared with buddies, on the bank
of the White River. In the rowboat
he pulled the trap out of swirling
muddy water, fish flopping
as sunlight flashed on their scales.
He'd lay out the catfish, perch
and buffalo on the makeshift wooden
counter nailed to a tree, and the knife
would go to work as if it had a will
of its own. He had no need
to guide it or tell it what to do.
When the guts were all slit and slung
out and the scales scraped clean
and the fillets settled in a bucket
of water, he rolled them in salt
and peppered flour and dropped
them into popping grease until they
turned golden grown. He flipped
them onto a platter next to a plate
stacked with sliced tomatoes from
his garden and coleslaw with enough
vinegar to kill all germs and would
hand me a plate and say, "Here, boy,
eat, you gotta eat to stay alive."

When I close my godfather's fishing
knife I see him sitting under the sugar
maple beside the farmhouse in which
my mother grew up. He grabs
the handle on the well and ladles

a tin cup of cold spring water
he hands me and then ambles over
to the smokehouse and comes back
with a gallon jug of his Virginia Dare
wine and hands the jug to me and says,
"Here, drink some, a man needs good
homemade wine to stay alive, never
made a better batch than this."
As I sip that fruity sweet wine
and smack my lips, I taste how alive
I am when I come into the presence
of this uncle who is my godfather.

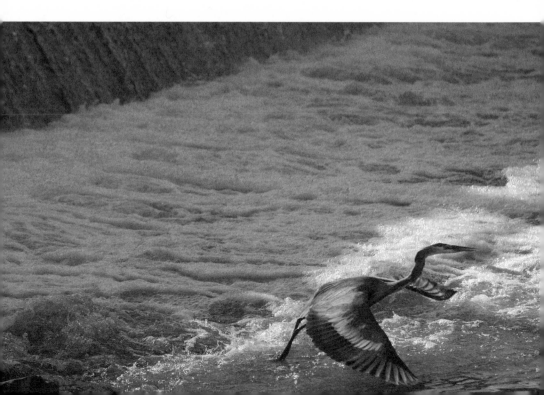

Patoka River Canoe Trip

We tied the canoes to saplings and crawled
up the bank to a sandstone ledge, grabbed
the thick wild grapevines, and swung
our feet as far out as possible before
splashing into the swirling muddy waters
that sucked at our toes and pulled
us downstream. The last one in was
a chicken, and the first one back out
who could slip and slide up the bank
got to fling himself out again, high
over the current, like a free-flying god
who would never have to come back
to solid earth. Our cries rang out
through the sycamore and cottonwood
leaves and bounced off the trunks.
We were way beyond the grasp
of mothers and fathers and could not
be pulled back any more than the current
could be stopped. Each time we flung
ourselves out over that swirling water,
we left all moorings behind and knew
we would never go home again
and be what we had once been
when we walked out the door.

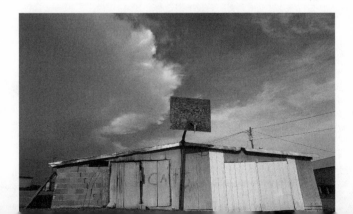

Barnyard Hoops

We shot hoops at night
in the barnyard off a backboard
nailed to the side of the barn.
There was a light that poured
rays on us like misty rain.
At first the coonhounds barked
when we began to dribble
on the hard-packed earth,
but they gave up and fell asleep
when we found our touch.
You couldn't always see if
the ball went in, but you could
tell by the sound of the swish.
A gallon of homemade wine,
swiped from someone's cellar,
was stashed off to the side
as a pickup for any sagging spirits.
When the full moon came out,
you could shoot the eyes out
of the basket, but you could
not find that hoop, today, in broad
daylight. A shopping mall and a big
black parking lot stand where,
once upon a time in the night air,
you could hear that leather swish
inside a cord net like the sound
of an angel landing in heaven.

The Schneebrunzer

There was a boy you may
have known who came
into his own when it snowed.
His art was so private no one
saw him practice it, but he left
his artifacts for all to enjoy,
so long as they did not melt.
You might turn a corner
downtown and find a yellow
I in the gutter. Behind
a tree in the park would
be burned a big *U.*
Sometimes when ambition
filled him like a balloon,
he would etch the outline
of a yellow rabbit against
sparkling white or wriggle
a snake that disappeared
into a steaming manhole cover.
They say that, once, after he
got into his father's cache
of beer in the refrigerator,
he left his signature
on the sidewalk behind
the church: *The Schneebrunzer
lives!* Mothers and fathers
would point, children would
giggle, and the mayor offered
a reward to anyone who would
reveal his identity; but the *Schnee-
brunzer* kept his name and his
art to himself. He came to
understand that his tenure
as artist, on this earth, was finite
and that all things must pass.

What the Map Says

When we look at a map
of routes that brought them
from the Old World to the New,
we cannot help but come
with them wherever they go.

We bring with them
the expectation of finding
something they did not
have where they had been.

We shake in fear
of losing what they
had to leave behind
in the shape of those
waving long goodbyes.

We sigh in relief
at no longer having
to contend with what
had become unendurable.

Every line we follow
is a series of steps
we take in the direction
of a new life we believe
is coming toward us.
We call that hope.

Every line we look back on
is a wake of water fanning
wider and wider behind us
until it subsides and disappears.

Where we are sailing
is who and what we
become and the legacy
we build as we move
toward a future we make

for those who follow.
We call this love.

The names we find
on the passenger lists
have a half familiar ring:
those we once were,
those we have become.

That language we hear
them speak in the hold
is the tongue we once spoke
or an inflection in the speech
we had to learn when we
touched on a new shore,
took a new kind of step.

When we look at this map
all the lines and routes
lead in the directions of both
where we once came from
and where we have gone.

We call this history,
we read it with eyes
that see both ways at once,
and we bring it with us
wherever our steps take us.

We hang this map
of our history on the wall,
for those who come
after us, and put our
fingertips on all the dots
that connect and show
what leads to ourselves.

God's Country

In God's country,
one hill always rolls
into another, trees that
grow taller toward dusk
set sail toward the horizon
when night moves in,
and the hoot owl cries
from deep in the dark
on a sycamore branch
dangling across the creek.

When you steer around
a curve in God's country,
the language on the side
of the red barn coming
at you tells you what
tobacco to chew
and a sign on the side
of the road tells you
when church begins.

In God's country,
a little boy who feels
Oscar Robertson's touch
arches the ball through
the hoop his father bolted
to the side of the barn.

When your tires crunch
across the gravel
of a driveway
in God's country,
you coast in your pickup
to the last spot and park
next to the back porch.

Through the screen door,
your nose takes in the scent

that tells you onions have
lain down in bacon drippings
in the iron skillet and made
friends with potatoes boiled
in their jackets, sliced into
thin white coins of the realm,
and stacked up to the bottom
of the iron lid pressing down.

In God's country,
when you sit down at table
to bless the stew that has
simmered on the stove,
your father's words surprise
you each time they flutter
out of his mouth, in the dialect
that his grandparents spoke
in that country the old ones,
once upon a time, left behind.

When you learn to speak
the old language in God's country,
you try to make an umlaut
by shaping a capital *o* with
your lips, but they relax.
What comes out is a long English
a as you give thanks: *Danke shane!*

In God's country,
the ancestors gather at night
in the woods to light a bonfire
that sends signals to you, on the hill,
so you will never feel lost
no matter how far you stray,

as long as you remember
where you came from
and never forget that to those
who came before you

where your family lives will
always remain God's country.

The Storyteller

Once there was a man
who loved to tell stories,
not about himself but about
other people, those who did
not believe their lives could
become the stuff of stories
anyone would want to hear.
He had the eyes and ears
to find stories everywhere
he looked and listened. His
mission was to give shape
and share what he saw in others
and pass on their stories to
anyone who would lend an ear.
This man had a voice that
was gentle but strong enough
to make you stop what you
were doing and follow where
his voice led. As the man
who loved to tell a tale grew
older, his voice deepened
and more and more people
followed him around to hear
what came out of his mouth.
When he died, they had
him cut open to find out
what made him such a great
storyteller. All they learned
was that he had a heart like
a hammer, lungs like a bellows,
and traces of a spirit their
probing fingers could not
quite touch or define. Soon
after they laid his body
in the earth, his stories
came to life in every home

and on every street and were
passed down by father to son,
mother to daughter. The man
who loved to tell stories came
back to life in these stories
that people loved to tell,
because now they were about him
but had become part of them.

Where Trees Are Tall

Let me go where the trees
are tall and full and the breeze
lifts the leaves above your head
and the hound barks in the back
of the woods to let you know
he smells your approach
riding on the wind and to warn
you that you shall never be able
to displace him from the territory
he has stamped with his scent
and knows deep down with his snout,

for to move in the hills where
scent marks the measure
of what you are and how you
relate to all that lives
is to give yourself to the flow
of the wind and the patter of rain
and the contour of the land
and the lines of the trees
and the scud of the clouds
and the angle of sunlight
and the flight of the birds
and the cries of the mammals
and the song of what sings
beyond our eyes and ears
from what was here before
and carries us to what
lies above and beyond
where we have ever been.

The Piankashaw in the Sycamore

Somewhere I once read
that after the first Europeans
arrived in what has come to be
known as southern Indiana,
from Kentucky or Virginia,
an Indian was observed stretched
out on a big branch of a tree,
perhaps an ivory sycamore,
that hung out over the waters
of a bend in the Patoka River.

This was some time after
the Piankashaw had left
the area behind. Something
must have been terribly wrong,
the author implied, for this
man to return to the area
where he was born and make
himself so vulnerable.

What could have happened,
the author wanted to know,
to make the man risk his life
just to crawl up the trunk of that
ancient tree and stretch himself
out on a branch that dangled
over the waters of a river that
had flowed through the middle
of the life of his people for who
knows how many generations?

What could have happened
on or near that site to pull
the man back? Was it memory
of his people and their history
tied to that spot that made
him return and lie down
so high above the ground,

over the flowing sacred waters
and spirits he knew remained?

Had he come back to pay tribute
to the unmarked grave of a relative,
gather medicinal herbs, maybe
offer tobacco to Lennipeshewa,
man-panther who dwelt in the depths?

Was he given over to the power
of spirits connected with this tree
and the bend in the river where
he and his clan had fished
when he was a boy?

Had he lost the desire to live
in some other place he knew
was separated from the spirit
of those who had come before?

Was he preparing to enter
the spirit world in which
those who had once lived here
would welcome him there
from whence he had come?

Coming into the Valley

Finally I come into a valley
where tall white oaks and shagbark
hickories stand like giants whose
limbs I remember from another age.
Cuttings fall through layers of leaves
as fox squirrels with creamy bellies
and bushy red tails bend the branches.

"Oh, I remember this place," I hear
myself say. My feet are happy they
have come to rest. Here I am home.

Now my vision enters a new stage
of clarity, objects come into focus,
my ears detect sounds from beyond,
and I see my father sitting on a log,
gazing up at the treetops. The lines
on his face are completely relaxed.
Puffs of smoke rise above the bowl
of his pipe, he sees me, waves,
whispers, "Glad you came!" "Me too,"
I say. "It took so long to get back
to this place. I thought I lost the way."

Then, in a stand of saplings beyond,
I hear a girl humming a familiar song.
When I walk over and part the leaves,
I see my young mother stirring
corn mash fermenting in a kettle.
"Please don't tell anybody," she says
with a grin. "Nobody must know."
"Oh no, I won't," I assure her.

Further on, I hear the whir of a circular
saw that recently began to roll. Guiding
it into a felled length of white oak
is my Grandfather Benno. His white
handlebar mustache is as thick
as leaves on the trees on every side.

As I approach, he turns off the saw,
motions for me to sit with him on the log.
"You've grown since I left," he says
with a simplicity as clear as the sunlight
flickering on the tips of his high-top shoes.

Over his shoulder stands his sister-in-law,
Great-aunt Tillie, who spoke only German
when I visited her farm as a boy.
Now I understand every word she utters,
can express every nuance of affection
and affirmation in words in the tongue
that brings light into her blue eyes
the very same shade as my father's.

Now I have reached the point where
every word is a poem that all creatures
understand and love. I understand
everything they say in their language,
they understand everything I say in mine.
Not one of us needs to utter the poem
that the other already knows and lives.
There is no distinction between humans,
animals, and plants; between family and friends;
between friends and strangers, poetry and prose.

I share this moment with you, but I would
have you understand that not every step
that led to this recognition of union
in the leafy valley has been so blessed.
Behind the light that filters down from
the treetops to where I now repose
gathers a darkness that often pressed
on my shoulders and lay on my heart.

May you find the right steps to take
toward this spot where I lie in wait.
Mention this poem and we shall talk.

Dark and Deep

When Robert Frost walked
in the woods he had a sense
of where the trail would fork
but not where the branches
would lead or what darkness
or light or combination of the two
might lie beyond. It was
the thrill of not knowing where
he was going or what might come
that gave a slight bounce to his step,
as the dusk thickened and the dark
began to pull him on like a magnet,
at the back of a deep cave where
shadows flickered like a campfire.
He loved to stand in a hollow,
as if at the bottom of a well,
and look up at the snowflakes
falling heavily out of a starless
sky, landing on his eyelashes.
Part of him wanted to stay
there forever and just stare
as the woods filled with snow,
and part of him said you better
leave soon. The only way
he could find his way back
to where he had started from
was to compose in his mind,
in a language he had to discover,
a poem whose lines snaked
out of the dark and whose
rhythms moved his feet
to take the steps that led back
to where others liked to walk
and promises could be kept.

Moon Shadows

for Elfrieda and Leon Fleck

I sit under a full moon
at midnight and see
shadows of trees on the far
side of the lake lying
on the waters like spirits
from the other world
come back to visit.

Each time I look
away and back again,
the shadows extend
farther and closer
to the near shore.

When the shadows
cast by the moonlight
reach and absorb me,
I will know I have left
this world for the next.

May I return
to this land I love
when the moon is full

and someone like you sits
in moonlight, with open eyes,
ready to perceive and receive

the shadows of trees
gliding over the waters
toward the shore
where you live.

The Time Has Come

The time has come
to come home, Mother.
I've followed the river
all the way to the sea,
stood where tall buildings
poked into the clouds,
and it's time to come
home to where the tulip
poplar stands prouder
than anything man can
build up from the ground.

The time has come
to come home, Mother.
I want to hear
the hickory nut fall
through crisp leaves
and splatter onto the ground.
I want to hear
the turtle dove coo
in the pines at dusk.

The time has come
to come home, Mother.
I feel pain rising
in my bones and I
want to stand and give
thanks where you lie
in the good earth
and watch the sun
set on the hills
where it rose
when I was a boy.

The time has come
to come home, Mother;
I can hear your quiet
voice sing those words,
and the tune is right.

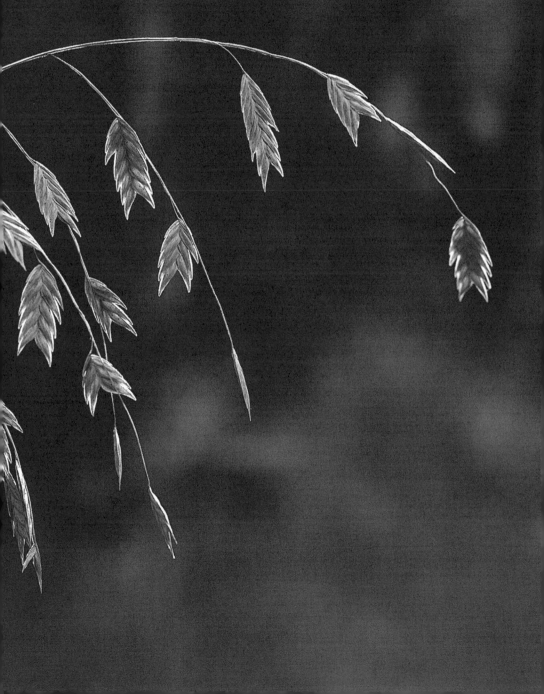

From *Invisible Presence* (2006)

Gate

It's not what's
in a gate so much

as what might
lie beyond it

makes us want
to push it open.

The Language of Red

To walk under a tree
that is on fire with color

is to feel yourself purified
of all that is lumpen and stagnant

& be released into a realm
where all is elevated to spirit

& you are free to climb
beyond where you have seen

& you sense you have just
begun to reach levels of approach

that open into paths & roads
you had not even imagined

& know that now you
are prepared to speak

a language that is flame
burning higher & higher.

Corn Blowing in the Wind

Just before harvest time
I was driving along a back

road & the voice on the radio
said the wind was gusting

to forty miles per hour or more.
I pulled over and got out

& stood at the side of the road
to witness and watch cornstalks

bend over as if they were yielding
to the gods everything that had risen

up in them from the ground.
I felt myself lean with them,

& knew that a force bigger
than myself ruled from beyond.

I felt my hands move with a will
not their own, my eyes saw

movement they did not usually perceive,
my ears heard sounds they did not

normally register, & I wondered if
the divine breath I had heard about

was touching down to burn my lips
& turn me into an Indiana Isaiah

who would breathe yellow flames
& speak in backwoods tongues.

The Blue Road

Will this winding blue road
I have been driving down

for I don't know how many years,
through these deep woods I love,

taking all the steep curves
at just the right speed,

shifting for all the grades,
tapping the brakes as needed,

ever open up into the endless
blue I have heard about

& yearn to see?

The Space Between

The space between
the noses of
a mare & her foal

who arch together
in a field
beside a fence

is the distance
between two worlds
reduced by love.

Bovine Beauty

Where do *you* come from
and what the hell do you mean
can you take my picture?
Why don't you pick on
the one standing back there?
Can't you let me chew my cud?
Can there be no peace in the pasture?

OK, show me some real ID.
What's your favorite brand of milk?
Who's your favorite cowboy singer?
Who's the prettiest cowgirl ever?
Did you ever sing that one about
The Little Dogie, around the campfire?

What, you don't eat meat?
Why of course you may, baby.
Just make sure you focus
on these beautiful brown eyes
& send me a print for the calves.

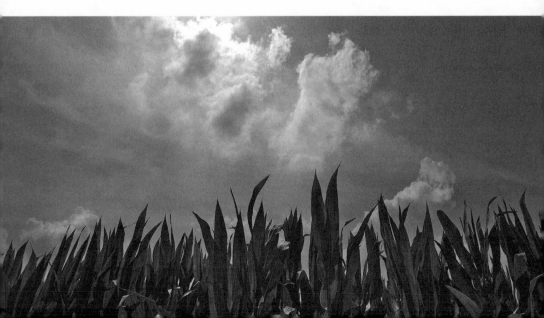

Corn Syllables

Corn can stand
so still under

blue sky &
puffs of cloud

that when any
leaf moves

on a stalk
you hear the

first syllable
of what

builds toward
the first word

of a new
language

in a hymn
of praise.

Cut Earth

Where man cuts earth,
lines & patterns show,

but where they lead
none of us can know.

MoreL

The mosaics
of a morel

make small
mysteries

loom large.

Cabin

I'm going to build a cabin
out in the woods, not far from
the creek & the blackberry patch.

Between the black walnut
& the tall shagbark hickory.
I'll pound in all the nails

with my very own hammer.
Cook everything on a wood fire.
Dry the clothes in a clearing.

No electricity. No phone. No fax.
No computer. No e-mail. No TV.
Maybe not even a radio. I'll bring

a copy of *Walden,* which I'll read
by the light of day, or by candle at night.
You come, too, & I'll read to you,

word by sacred word, the chapter
about how morning brings back
the heroic ages. We'll snuggle

beneath an old family quilt. Mornings
sunlight will find & caress us;
we'll baptize one another in the creek.

We'll learn how to consecrate
every minute of every day. Smoke
will rise like prayer up the chimney.

Whitman's Web

When Walt Whitman observed
a spider spinning its web,

he thought of his soul sending
out ductile filaments to connect

with something beyond himself.
Once, walking in the woods,

I found sunshine backlighting
a web & stood transfixed

before a pattern so intricate
I could only give myself to

the design before me & wait
& hope for more light to show

where the intersection of gossamer
threads & my path may lead.

Deaton's Woods

Beyond a sloping line of trees
that curves at the bottom of a hill
stretched Deaton's Woods. I never

entered those magical woods
without hearing squirrels
drop cuttings from the tallest

shagbark hickory I have ever seen.
Somebody shot Martin Luther King,
but the squirrels kept coming back

to the tree that towered above others.
Somebody shot Bobby Kennedy,
but the squirrels refused to abandon

the shagbark so laden with fruit.
Our cities went up in black smoke,
my love life went up in flames,

& my academic career almost
went up the creek, but those wise
squirrels kept returning to their tree.

Come back with me now
to Deaton's Woods, to sit under
that tree I have kept to myself.

We'll share the patter of cuttings,
look for the flicker of a tail,
& watch the branches bend.

No matter what kind of tragedy
rips at the fabric of our nation,
even if police club students

in the streets & politicians
attack one another on the networks,
we'll behold squirrels in that tree

that stands somewhere in the blue
haze of Deaton's Woods beyond
the tree line that slopes & curves.

Woods Meditation

I am a mind
meditating
in the middle
of these woods

& my spirit
is squirming
to break out
of its cocoon

& flutter up
into the sunlight
above the body
it leaves behind.

David Ignatow's Trees

My New York Jewish friend
saw the trees as tall gods
commanding a view
of his Long Island study

& bent over his typewriter
to compose ceremonies
for the gods
in plain-spoken poems.

The sound of his urban
American voice rising,
in prayer, in my ears,

I look out my study window
at trees in the heart of the interior,
to which I have returned,
bow my head at my desk,

& compose this Indiana
German prayer of thanksgiving
for his friendship,
the power of his words,
& the gifts of our gods.

Bare Tree Song

Give me a tree,
bare of all leaves,
standing in a field.
Let snow fall
on its branches.
Now let darkness
settle upon the scene.
Animals step out
of the woods
& sit around it
in a circle
moonlight finds.

Now close your eyes
& let the tree
& the snow
& the animals
& the moonlight
enter inside you.

What do you see?
What do you hear?
What do you feel?

Open your eyes.
Now sing your song.

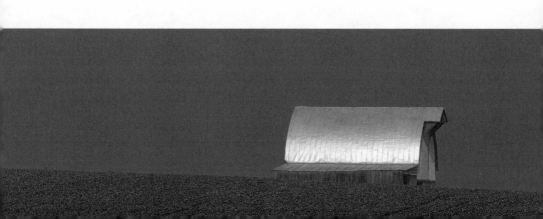

Tale of the Red Barn

Once there was a red barn
with tin roof & white doors.

It was a place to romp & hide
for boys, sanctuary for cats,
hostel to those who stand
on fours & chew what
grows in the fields.

It was a drum for hard rain
& hail, venue for fiddling
& dancing on Saturday night,
house of worship whenever
a calf or colt was born.

Up in the dark gallery
sat rows of bales that
could erupt into flame
if they came in early
wet behind the ears.

Every night this red barn
with tin roof & white doors,
a ship with a cargo of animals
exhaling warm breath, sailed
off somewhere into the dark,

& every morning we found it
moored back at the dock when
we came to milk the cows.

Two Kittens

Two kittens, balanced
on a wooden ledge,
look in the same direction,

poised for any action
that may come their way.
They both look at

the same thing,
however large,
however small,

down at shoe level,
where the mysterious
always seems to gather,

& they are ready
to go to it, if it will
not come to them;

but what they like best
is staying put where
they can look down

at shoe level
where the action
always begins.

Midwestern Scene

In front of
a small barn
& short silo

stands a windmill.
What modest breath
makes the wheel turn?

Who dabbed
dusty clouds
in blue sky?

Slanted rays
of light
onto the silo?

Kept everything
in scale so that
all elements of this

quiet scene speak
in harmony with
simple elegance?

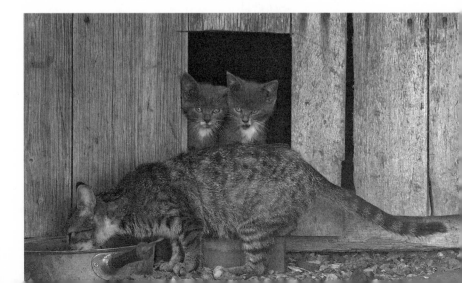

A Red Barn for the Joads

We could allow the ghostly Okies
wandering in the rain to discover
this dry barn. Their jalopy truck
sputtered & died on the road again.

The Joads, who lost their farm
to the banks & Grandpa
& Grandma to the road, could
stagger in by the side door.

If they happen to find
a young boy whose emaciated
father lies dying on the floor,
Ma, who rises to every occasion,
could take charge & speak fiery
words again. Pa could stand & stare
while firebrand brother Tom is off
fighting for a scrap of dignity.

Rose of Sharon, who just lost
her first baby, could give
the old man her breast, under
a blanket. The animals would
all understand, but some people
might not. Worse things happened
in our families during the Depression.
Lots worse could happen in red
barns all over southern Indiana.

What's in Wood?

What do you see & smell & feel
when you touch the hand-hewn
beams that have remained parallel

to the ground in this old structure
for so many years? How many rings
were there in the tree that was once

upon a time felled by the people
who built this shelter to keep rain
out & grain or animals in? What

will be lost when this small building
is allowed to tilt & collapse & crumble
into the ground? Will the woods remember

the spot where the tree once stood before
human hands brought it down? When
these hand-hewn beams have rotted

& gone back into earth, will any
descendants of the builders of this shelter
know what went on inside it & pass on

the story to those who will live
in the houses in the development
that will surround & replace it?

I Remember When

I remember when
the flowers bloomed
in maroon & white

not far from my hands
& there was gold dust
at the center of every

single blossom & bees
buzzed through the day
until they went back home

& fireflies took over
at dusk & blinked
their semaphores of lights

like circus performers
just above the tips
of blades of grass

that pushed against
the soles of my bare feet
& tickled my toes.

Close Look

The closer we look
at what we love

the more darkness
becomes visible

in the heart
of what we see.

Flower Interior

Even when we see
inside the heart
of a flower

& study the parts
to which we can
give the right name

we still have not
touched the mystery
of how it works.

Rilke's Shadows

When Rainer Maria Rilke
prayed for a good autumn,
he asked God to lay His
shadows on the sundial.

When we take a walk
on a day of sunshine
that lays shadows
in beautiful patterns,

should we keep our feet
in sunshine, let them touch
the shadows, or just close
our eyes & let them fall?

Army of Orange

We've had it, we're fed up,
get out of our way, we have
joined forces. Today the patch,
tomorrow the whole wide world!
We are the Army of Orange.

No more pies on Turkey Day!
No more soups with nutmeg
& butter. Keep your nasty
knife to yourself, stop cutting
out those toothy grins
& stupid triangular eyes!
Never again will you dare
to roast & salt our seeds
or stick a burning candle
in the middle of our belly.

If you think you can keep on
slinging our slimy guts
into the garbage, Mr. and Mrs.
Homebody, why don't you just
pucker up & give our bottoms
one great big resounding smack?

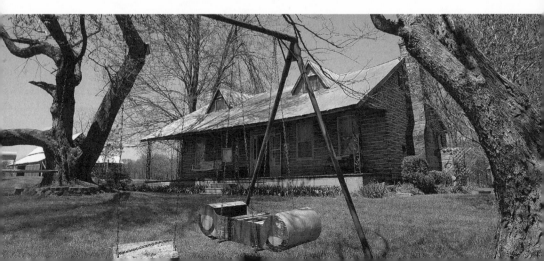

Left in a House

So many dreams
sleep in a house,
so many sorrows,
so many joys
behind the curtains.

So many shadows,
so many rays of light
inside the windows.

Sounds of conflict,
sounds of reconciliation,
cries of pleasure,
cries of pain
beyond the doors.

So many memories,
unfulfilled yearnings,
secrets shared & kept,
promises made & broken
behind the picket fence.

So much left unsaid,
so much to say
about what's left
behind in a house.

What If Fish?

What if fish flew
in a blue sky over
the house & birds
flipped out of water?

What if shadows
instead of family sounds
leaked out of a house?

What if an animal
lounged in a chair
on the porch
while his master
snored at his feet
on the floor?

What if a poet
built gingerbread houses
made out of words
that when you ate
them gave you
the power to create
an Indiana epic

& a photographer
transformed every
image into a painting
that gave you
the capacity to see
spiritual presence
in all things Hoosier?

For Whom, the Bells

Wherever you were
in my hometown
you always saw

& felt the presence
of that church tower against
blue sky & whenever

the bells tolled everything
stopped, people came
out of their houses

to look together
in the same direction,
& we wondered

for whom those bells
tolled & gave thanks
that we still breathed.

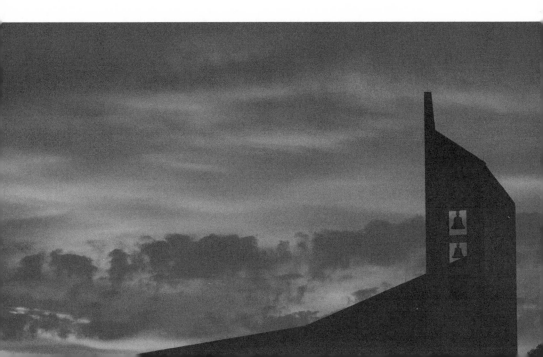

Picket Fence

Does the picket fence
along the side

of somebody's house
make me a better

neighbor for not
invading his shadows

or a poorer person
for discouraging me

from entering
into his light?

Rest

Sometimes the eye
is relieved to rest

where boards warp
apart & white paint
can no longer lie
tight against clapboards
or the sides of pickets,

the darkening leaves
settle in gutters
as dust collects
in the corners
of the porch,

shadows crawl
on all fours
into spaces & cracks
open to them,

& the broom, pail,
mop & paint brush
give up the ghost
for the winter.

Walking the Streets

Walking small town streets
you can't help but notice
which lights go on
at which time, who raises

his voice two evenings
of three, who stands
under the street light
after it's a little late,

& what time the tavern
door slams shut after
the last regular leaves.
If you also walk early

in the morning, you
see who's driving home
while others go to work,
& in the diner, who needs

a good cup of black coffee
pretty bad. Keep walking
& one day you may meet
a man who looks just like

you; he will ask where you
have been. You will have to
tell him, as gently as you can:
where everybody always goes.

Windows

Walking around town
I sometimes see faces
in the windows of offices

that are closed at night
& hear voices of
people long gone

from these streets,
& if you tell me I
hear what could not

be there, I say
you have not
listened to the sounds

that come from beyond
or developed eyes to see
what lives deep within.

The Court House Bench

The old men with rumpled hats & canes
sat on a bench in front of the court house
talking about whether there were many
squirrels this year, who grew the biggest

tomatoes in town, and who would win
the World Series. They looked out
at us teenage boys cruising in souped-up
cars around the court house square,

guffawed, & dismissed us as mere "squirts"
when our glass-packs rattled & roared.
After our father died at 75 & we buried him
on the side of a hill, my brother asked

if I remembered those old guys who used
to sit on the bench at the court house.
Yep, I sure did. "Well, that's what
he became," he said, "one of the village

elders." So now that I'm into my 60s
and climbing, I look for my seat on the bench
& wait for tomato, squirrel, and baseball
wisdom to descend upon me in tongues

of fire so that I can proclaim
with a vengeance who all the winners
& losers are and will be & how what
used to be is always better than what is.

Man in Red Cap

An old man in a red cap
has a million wrinkles
all in the right place

& his lips press shut
& pucker while his dark
eyes bore right into us.

His flannel shirt
features the perfect plaid
& his coat the right squares

as he sits on a bench
with his legs crossed
to show a single boot

in front of all manner
of firewood & junk
piled high at all angles.

All of this moves us
to vote for him as mayor
come the next election.

Neighborhood Muse

A pretty girl with soft long hair
that catches the sun as it falls
on her shoulders & across her chest,
an oval face, rounded forehead,

sensual lips that look like they might
turn into a pout, & shadows where her eyes
look back at you, as photographed
by her father, reminds me of Georgia O'Keeffe

that time she let her long dark hair fall down
over her shoulders onto her breasts scarcely
concealed behind her partially opened gown
as she looked with sleepy insouciant eyes

at Alfred Stieglitz, as he trained his camera
eye on her. Georgia makes me think of a woman
called Helga lying in bed behind a sheer curtain
as Baltic breezes blew across her flesh

& Andrew Wyeth picked up his brush
& stroked in the right colors of restraint
in the right places. Helga makes me think
of Venus whom Botticelli stretched out

on the half shell to our adoring eyes.
These women help us see that the Muse
may come in different guises but always
lives close to anyone with an open eye.

Hoosier Poetry Reading

Look up, from below, & you may see
the legs of a girl dangling from her perch
on a branch near the trunk of a sugar maple
in front of an old farmhouse in southern Indiana.

The girl has finished her chores, but knows
that her bossy big sister will do anything
to get her in trouble, if only she can prove
a theft of daylight time wasted on reading.

Look around & you'll see big sis cruising
the yard, the garden, & the barnyard to catch
the frivolous culprit in the act. Every time
the angry detective passes under the sugar maple,

little sis swallows a giggle over how clever she is
to be reading the dialect poems of Hoosier poet
James Whitcomb Riley in her bower of leaves,
where sparrows usually cheep in chorus.

Let us allow Dorothy, my mother, the girl
reading Riley in the tree, & Frieda, my second
mother, to work out an ending to this 1920s
vignette that nobody had to invent.

When we read our next poem, let us
remember this tale of a girl wise enough
to climb to a higher level to read
her favorite poems in sanctuary.

Song of the Red Covered Bridge

Beneath the red covered bridge
the flotsam & jetsam of
ice patches, branches, logs.

How many carriages & cars
have rumbled across the planks
supported by beams on piles?

How much water has flowed
beneath this red covered bridge?
How much more is left to stream?

How long before the maniac among us
scrapes a match across rough surface
& flames leap at every angle

as we begin to compose another
hymn of praise to what we love
about what we once had?

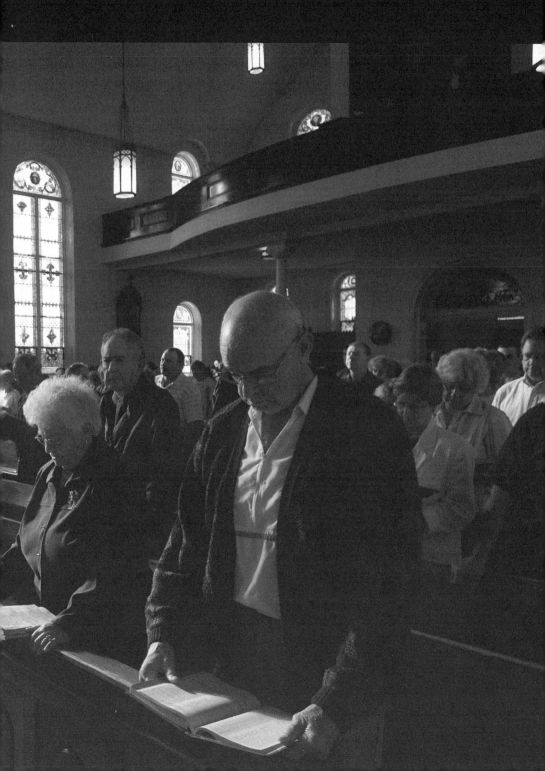

Local News: Poems 2005–2007

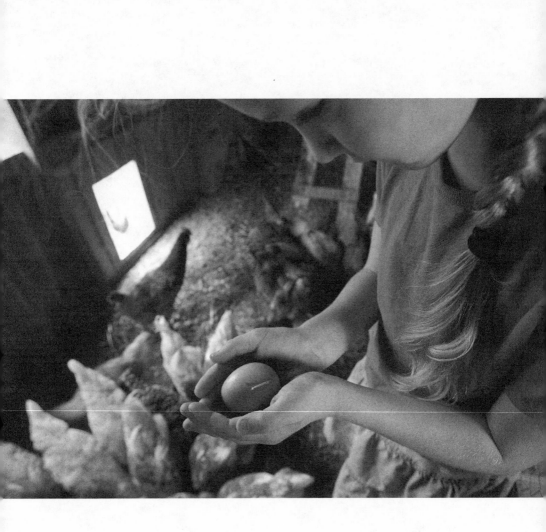

Sister Soap

When store soap could not
cut it clean enough they

would gather, two sisters
and one sister-in-law,

in a town basement and mix
the mighty potion they remembered

from the elders on the farm:
drain the water off ashes

saved from the hearth,
pour the leached lye

into a heavy iron pot,
fold in pig-fat lard,

light the fire on the old stove
beneath the black iron chalice,

stir the blubbing sludge with
wooden spoon till it thickens,

pour it slowly, carefully
into a square granite dishpan.

After it is cured, cut it into yellowy
flecked squares with a butcher knife,

divide it three sisterly ways.
Burns the grime off stained clothes,

peels the psoriasis off scaly
skin stretched over an elbow,

makes the hair on your head
stand on end squeaky clean,

gives back the power the family
lost when it moved into town.

Clothesline Saga

On the clothesline
between the sugar maple
and the vegetable garden

hung the pillowcase
bulging like an udder
drip-dripping whey

and when the curds
were ready to explode
on your tongue

with the bite
of thick milk
curdled to just

the right edge
by the bacteria,
you could taste

the lazy mooing
of the cows,
the whinny of the horse

and the crowing
of the rooster
she carried with her

to the edge of town
from the farm
where she grew up.

Charlie

He had become an adjunct
to the main work of the farm,
now that tractors roared to life
early in the morning and shut
down and cooled late in the evening,
but he always stood ready
for whatever work found
a way to come into his strength.

Two boy cousins liked to
include him in their routines.
He would nicker, slap
his tale at flies, flex his
muscles when a young hand
felt and patted his hide.

When they attached a wooden
sled stacked with bales of hay
behind him, he lowered his head,
rippled his muscles, and pulled
his load, gladly, into the pasture,

where he stood, patiently, waiting
for the world to turn back to his
slower way of working or ready
to accept the vague death he felt
slowly coming toward him from
the far reaches of his fading vision.

In his eyes, the boys whose hands
often reached to feel his sides
saw a depth of understanding
and what can only be described
as a rippling reservoir of love.

Little Red Worms from Tennessee

She read about them in a magazine,
fantasized she could sell them
to local fishermen, to raise cash.
She kept them in wooden crates
stacked along the concrete block
wall in the furnace room around
the corner from his workbench.

We fed them bone meal. When
nobody was looking, I lifted
the lids, turned over the loam
with a hunting knife, watched
the small red worms from Tennessee
twist and wriggle like inflammations
crazed to break loose from their cage.

Finally, she gave up on her scheme
when almost nobody came to buy.
In the spring, we liberated them.
We carried the crates to the garden
and dumped them onto the soil
turned over by the old hand plow.

I imagined the little red worms
from Tennessee mining the length
and width of the garden in their
underground Elysian Fields,
excreting tiny potent leavings
in gratitude to enhance our soil
and swell the roots of corn, peas,
and beans with earthy energy.

Dolls and Guns

She gave each of her sons
a doll and a toy gun.

During the day, they shot
the gun at robbers in the mountains

and at night they put
the baby to bed in the cabin.

The same fingers that pulled the trigger
tucked the sheet around the baby's face.

She gave each of us boys
a doll and a toy gun

and the finger that ran
through the doll's hair

would later find it hard
to pull the trigger of a gun.

The Local News

When the mid-day meal was about over,
we children knew it was time to hush.
She grew taut as a high-intensity wire
ready to spark. The local news was about
to come on WITZ AM, our local station.
Who died and where and when would he
be laid out? Who was admitted to the hospital,
and for what? Who was arrested for drunk
driving? Who got hauled into court for what?
Whose baby was born and how much did
it weigh? The national and international
economies might dip or bounce,
regimes might rise and collapse,
Joseph Stalin might be laid out
in his famous coffin on the front page,
planes may be shot down over Korea,
but the bigger picture, the greater story,
was always and forever the local news,
the news at noon. When the local news
was over, she would relax and say,
"Okay, you kids can talk again now,"
and she moved on with her chores.

Two Bottles of Beer

Two short brothers, one from
the woods, one from the house,
come together and pull up chairs
facing one another beneath the trees.

Two short brothers lift bottles
of beer, clink them together,
take a chug, start to speak German,
take off to a place I have never seen.

Exactly where they go, I'm not sure,
but I know they go back, and I want
to come along. They ride guttural
crests of language, crash to highs
and lows of laughter as they sip
and speak, start and stop, open
eyes wider in mock astonishment,
in their secret sect of shared
language that brings them
back to this childhood well
and opens up waters I sense
may one day open for me, too.

One word stands out as a returning
point of ritual sound and emphasis
in this beer-bottle brotherhood
of memory: *Jetzt? Jetzt! Jetzt.*

Now? Now! Now, I come to understand
years later, as that word I swallowed whole
rises back up in me like bubbles as I work
my way into the shared language of childhood
and brotherhood, this medium of my uncle
and my father, in another time and place,
through books and tapes, into the eternal
now of two brothers sipping bottles of beer,
under green trees, in summer evenings
that spill into *Jetzt, Jetzt, Jetzt* and pour
into this foamy mug of now, now, now.

Cemetery Wind

The wind that blows through
this cemetery speaks a language
I know. It touches the tall thin

tomb of my great-grandfather,
Johann, born in Germany.
It touches the lower granite

tomb of Benno and Mary,
my grandparents. It touches
the tomb of my Uncle Jerome,

killed by shrapnel in Germany
near the end of WW II.
Blow, cemetery wind, blow;

you can never blow out
the flame at the end
of the candle I cup in my hand

as I make my way back
to these rows of tombs where
my father played as a boy

when wind tousled his hair
and the tombs spoke names
he heard often at home.

The Egg in My Hand

My grandpa took me by the hand
and led me into the chicken pen.
His hand was as warm as the egg
he let me hold. His mustache
was white and soft like a feather.
We walked slow 'cause Grandpa
was old. He did not say many
words, but we listened to the chickens.
Cluck, cluck, cluck is what they said.
Not too much later, my grandpa
went away. They said he was dead.
He never came back, except into
the hand he held that was as warm
as the egg he let me hold. Now
I carry my grandpa with me
and try to keep that egg from breaking.
I can see the feather on his lip
and hear the *cluck, cluck, cluck*
of the chickens in the pen where
he led me by one warm hand.
He knew how to help me step
where I wanted to go. He walks
with me now. My hand is warm.

Lindauer's Woods

When he stepped into Lindauer's Woods,
he always heard cuttings fall from every
other tree. The limbs of shagbark hickories,
loaded with nuts, bent under the weight
of fox squirrels whose tails were tinged
with red like fire sparking out from the sun.
When he looked up as cuttings fell down,
it was hard to know which squirrel to
point his gun at because so many vied
for his attention. When he was a boy,
his father never returned home from
Lindauer's Woods carrying anything less
than the bulging brown leather bag strung
over his shoulder. When his older brothers
returned home from Lindauer's Woods,
their smiles were so broad they could
barely talk about how good it had been.
When my father entered Lindauer's Woods,
he suddenly grew taller, his ears picked up
every sound in the whole woods, his eyes
detected every move on the near and far
side of the woods, and his gun never missed.
If only I had been born a few years earlier,
I too could have hunted in Lindauer's Woods.
Everything would have been different if only
I could have hunted in Lindauer's Woods.

Father, Teach Me

Father, father,
teach me
how to hunt.

The forest is deep,
the path is long
and morning light
is slow to come.

Wild animals cry
in the underbrush
and big eyes glow
in the trees.

Father, father,
teach me
how to hunt.

Some women smile,
some women wink,
I want to touch
them all but I fear
to give any my hand.

Once you were here,
now you are gone;
I need to learn how
to take the next step.

Father, father,
teach me
how to hunt.

The villages are
crowded, the inns
are smoky, the doors
of the chapels are
shut to sons like me.

Once I was found,
then I was lost,
now I have to
begin over again.

Father, father,
teach me
how to hunt.

In the fortress
and in the field
all I hear is
cannons explode.

Everywhere I turn
there is blood
on the path
and fear in the eye.

Once I was young,
then I grew old,
now I'm small again
and need your help.

Father, oh father,
give me your hand
and point me
toward the light.

My vision is poor,
my strength is low
and I would learn
where I must go.

Father, father,
please teach me
how to hunt.

Once you were here,
now you are gone,
but together again
we could find our way
out of these woods.

Old Henry

Old Henry was a one-man crew
appointed by the priest to keep the new
Holy Family school spittin' clean.

Mornings Henry walked up the hill
in his gray work pants, blue shirt,
high-topped shoes, and flat hat covering
his bald pate, carrying a metal lunch box
with its cargo of a fried egg and two
strips of bacon between two slices
of white bread layered with mayo.

Old Henry held a mop like it was
a lady who might not follow
his lead in the dance of keeping
the halls and classroom floors clean,
so he held her extra tight and made
sure she stepped in all the right places.

In the restrooms he stuck a brush
dripping creamy white Lysol
down the throats of toilets
and urinals and flushed until
the waters carried all imperfection
and stain out of sight, out of mind.
All the while he mopped and swabbed
everything spic-and-span clean,
Henry's hearing aid spat static
and picked up possible signs
of any disturbances that might
undermine all his hard work.

The enemy was cruel and destructive
children, lurking in the shadows
of halls or around the corners
of classrooms, waiting to ambush
him and spoil what he made right.
Scouts would notify search and destroy

teams of Henry's whereabouts and set up
decoys to lure him from the site of attack.

Once upon a time, I remember,
Henry caught one of the enemy
up to no good, clasped his hands
around the kid's neck, eyes
bugging out of his head, and they
had to call the priest to make
sputtering Henry relax his hold.

When he could no longer make
the trek up the hill with lunch box
in hand, Old Henry disappeared
into his house. They say they found
him stretched out on the kitchen floor
after a heart attack brought him down,
his hearing aid spitting static, shadows
of cruel children playing on the walls.

Wilson's Drugstore

In Wilson's Drugstore
at the traffic light
by the town square

you could order
a hamburger and fries
with just enough grease

and push a button
that would make
the Everly Brothers

sing about dreams
in a harmony sweeter
than your cherry coke.

In Wilson's Drugstore
the waitress you liked
would take your order

with a smile and when
her boyfriend left
for his job she would

return with a plate
heaped extra high
with fat fries and give

you a look that
said you will some
day be the one.

Sister Query

for Marilyn

What does it mean, sister, to die
as you are born? Were you never
alive in our mother's womb?

Did you never draw one breath
in this or any other world? Is
there no one but me who knows

you were and still are there?
Am I the single believer in this
religion of one with you as

center and source of my creed?
Are all those I love in this realm
doubting Thomases when it comes

to you and your invisible life?
Is it your breath I hear
and sometimes feel in the night

when everyone else sleeps?
Will I one day wake to look
into your soulful eyes that have

looked at me across this divide
since I was born? Could you
be alive on the other side

and I have been stillborn in this
realm apart from you and those
who left here to join with you?

Will I one day see the light
in your eyes wherever they
went before they could open

and walk with you however
you have walked since the day
you were born and died

in the same moment
in and out of whatever
world is still mine?

Rockroading

We were itchy, thirsty, and way underage,
but always somebody in a joint would sell
us a cheap case of beer and a bag of ice.

Somebody had his own car or could get
the family car for a night, so we opened
the trunk, opened that case of beer wide,

forced ice down into all the openings,
and headed out for the darkest, most
hidden, winding, dangerous rock roads

we could find. The object was to see
if we could possibly get ourselves
lost in the home county we all knew

while sucking down all the brown
bottles of hops-heavy regional beer.
The radio, tuned to Chicago or

somewhere in nearby Kentucky, kept
us supplied with rockabilly love songs
and hormone-high, teen-angst car anthems.

We all sang the choruses together,
sometimes changed the name of the girl
who lived forever in a favorite lyric,

and lifted our brown bottles like chalices.
Sometimes we skidded around curves,
levitated as we reached the top of a hill

and came back to the earth with a thump.
Somebody would yell out where to turn
as somebody begged to whiz in the woods.

We never succeeded in getting ourselves lost,
as the compasses we inherited helped us find
our way out of any hills, hollers, or bottoms.

Sometimes when I open the trunk of my car
I can smell cheap flat beer, sometimes I want
to belch, and when my son tells me he knows

when to stop as he weaves his way into the house,
I recall the ancient rite of rockroading with pals
but keep my balance intact and my lips sealed.

The Rustic Tavern

for Dave and Lou Eckerle

The bouncers at the Rustic were
huge and vicious as bulldogs,
fights broke out like brush fires
at the tables, and the bands that played
Saturday nights changed as often
as the weather. You almost never knew
the names of the girls, and the dance
floor was a foreign country few
of us guys had the nerve to visit.

During the week, we played poker
in the kitchen with the owner's son,
sucked cheap beer out of brown bottles,
and chewed chips and pickled sausages.
Something in the deck was always wild.

After all of us but the owner's son
left town for college, some to play ball,
one night sparks in the kitchen leapt
into flame and the Rustic Tavern
burned right down to the ground.

Some years later, the owner's son,
driving a pickup toward home
after the late shift at the coal mine,
lost control in a foggy curve,
around midnight, a glaze of snow
on the surface, skidded into a bridge,
and crashed headfirst into eternity.

Fishing Again after Many Years

for Laverne & Charlie Schuck

My son, my childhood neighbor Charlie,
and I sit in a boat on a small lake in my
hometown. My son looks to me to bait
his hook, remove hooked fish, and set
him up again so he can connect with another
finicky creature so hungry it can be flipped
up out of its element into the sunlight.

I have not fished in decades, depend
on Charlie, who remembers me
in tall rubber boots checking rabbit
traps before school, to let us drift
to the right spots where schools of fish
float beneath where we dangle our lines.
Soon our little boat is filled with
enough bluegill to feed multitudes.
I am ready to walk across the waters.

When Charlie moors the floating pickup
in his driveway, the tailgate comes down
and we slit the fish open, remove guts
and floaters, scrape away the scales,
and fill a bucket with white fillets.
Bees hover like mini choppers over
the carnage of plenty; one of them
maneuvers to inject a lethal dose
of humility beneath one of my fingernails.

I lug the throbbing wound that dangles
at my side up the hill to my mother's house
and lie on her bed in silence heaving
heavy hurt breath like a big fish
flopped up out of its element.

Patoka River Carp

Back when I was going
in a different direction,
I stood on the old bridge
and watched people drop
liver-lathered dough balls
to hook and pull them up.

Now in my seventh decade
I stand close to the edge
of a footbridge as first light
breaks and look straight
down and watch seven huge
shadows hover and glide.

They nudge and suck
at the soft edge
of logs and limbs
and sink and settle
into crevices as I drop
my long line of attention

and try to pull them
up into these short lines
where they might float
in and out of time with
the ancestors I admired
when I was a boy.

The Blueberry Bush

She put golden ears of corn
on a spike for the cardinals,

gave the finches thistle seed,
scattered sunflower seeds

on the ground for any and all;
but her prize blueberry bush

she would share with none.
It stood right at the point

where the lawn banked
down to the road, for all

neighbors to admire as
they drove past to work.

She found two old white sheer
curtains, stitched them together,

and draped the net over the bush
as the berries began to blue.

As her lawn sculpture ripened,
she chortled in triumph, mimicked

the solo of the mockingbird singing
atop a telephone pole nearby.

When the blueberries were ready
to harvest, she flung off the white net

and baked sweet fluffy desserts
as birdsong turned flat and sour.

Call of the Quail

From the corner of the woods
near where my father later planted
boysenberry bushes, close to where
my mother picked ripe strawberries,

came the call of the quail:
Bob, Bob, White! I am here;
Bob, Bob, White! I am here!
And once that call comes

it never goes away, and wherever
you live, in the city, in the suburbs,
in a small town, in the country,
whenever the sunlight slants

in a certain kind of way
and the breezes blow and touch
your skin, you close your eyes
and you hear once again

the soft yet firm cry you will
carry with you, wherever you go:
Bob, Bob, White! I am here;
Bob, Bob, White! I am there!

The Rosary

Uncle Otto is in the hospital in Louisville,
hours away, decades before an interstate

comes through southern Indiana. He has
a liver disease, and they call to say, "Come now,

right now!" My mother, Aunt Frieda, Uncle Otto's
wife, and my grandmother get into the car

with Uncle Bill, who guns it, is maniacally
merciless, presses and keeps the pedal down

as they speed around curves, over hills,
toward Louisville, so that Aunt Frieda

can see Uncle Otto one more time,
tell him one last time she loves him.

What can my mother, aunt, and grandmother
do to prevent Uncle Bill from killing them all

but pray, say the rosary out loud? "Hail Mary
full of grace, the Lord is with thee," they say,

almost chant, refusing to let up. "Hail Mary,
hail Mary full of grace . . . pray for us sinners

now and at the hour of our death, Amen."
I hear the insistence in their voices,

but also feel the steel rod of his will,
as they soar and swerve through the night,

or early morning, through layers of fog,
whatever time it is now before Uncle Otto

breathes his last. Even though I never liked
saying the rosary, sorrowful or joyful mysteries,

never was uplifted by the mantra that it was
and is, I say it now to help Aunt Frieda,

her sister my mother, and my grandmother
prevent Uncle Bill from losing control:

"Hail Mary full of grace. Hail Mary full of grace,
full of grace, full of grace, blessed art thou. . . ."

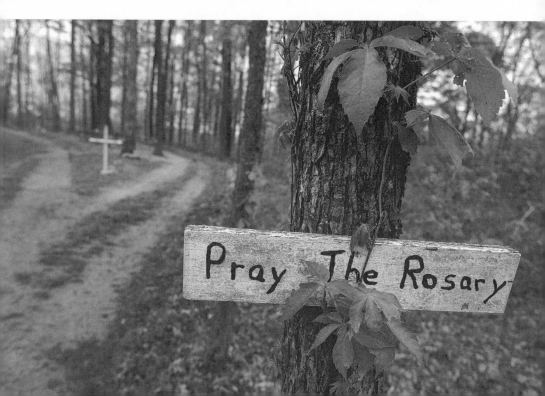

A Silent Prayer

When the news came,
just a month after the chemo
was over, that it was back,
after the oncologist had said,
"Looks like she'll have some
quality time now," she said:
"No, no more chemo, no more
needles, no more blood drawn,
This is it!" She wanted to go,
and who were we to keep her,
when every breath was a new
torture and all she could say,
in between, was, "Whew. Whew!"

And as the pain overtook
every part of her, she asked,
"Why can't I just die?" and I
said a secret, silent prayer,
"Please let her go, ASAP."

My brother, who shut up
his house in Florida and came
home to take care of her
in the house she wanted
to stay in, in Indiana, asked
her who she wanted to see
most when she was let go.

"Alfred, Bill, and Betty!"
she said just like that, not
missing a beat in naming
her older brothers and baby sister.
"And what about Dad," who
twenty-five years earlier fell
dead at her side of a heart attack?
"No, he had an easy death."

Finally, when her terrible
breathing prolonged by
pumped oxygen stopped,
the long-distance call came,
and I gave thanks for us all.

Eighth Anniversary

Eight years ago today
came the morning call
saying this was the day
you would not continue
your stay in this realm

and a second call came
a couple hours later
expressing relief that
you had passed beyond
the suffering we all
tried to bear as one.

I don't know if I heard
or felt the sound of your
flight into transcendence,
but I saw it as a beautiful
arc that curved upward
like a rainbow that did
not return to the earth.

It was a song without words
and a quiet melody that
only someone who had
prayed for relief could hear.

It was a song I will always
hear as a prayer of love
that arises whenever a few
people gathered together
listen to what remains
of a presence that waits
beyond, calling us to come
home to be with her where
prayer and song and poem
are what we create by the way
we have breathed and lived,
joined together in spirit
that will always be one.

Brother, Brother

Brother, brother,
what did we do,
what did we say?

Your house belongs to another,
your phone has gone dead,
no operator shows you listed,
your e-mail has gone defunct,
our letters come back.

My eyes tell me you
have passed through these woods.
I have found your footprints
pointing away down by the creek
where once upon a time as a girl
our mother stirred the corn mash.

Brother, brother,
what did we do,
what did we say?

Another war rages
in another part of the world,
like the one you fought in
that nobody could win.
Civilians are blown apart.
Soldiers come back in bags.
No end is in sight.

Your god-daughter is getting married
and longs for you to stand by her.
Your nephew misses the way
you make us laugh till we cry.
Your sister stands, looks, waits,
so does your sister-in-law.

Brother, brother, meet me
at the sycamore where we
used to cross the creek together.

You can talk. I will listen.
The leaves are falling
and our time in these woods
will soon come to an end.
It is time to come back.
We need your memories,
your humor, your heart.
Whatever hurt you feel
we can all help heal.

Brother, brother,
we know you are there:
brother, come back.

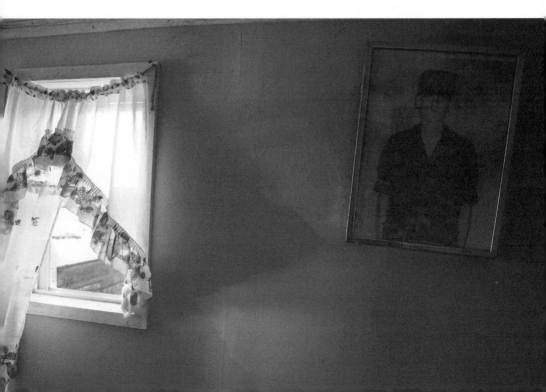

Indiana Sycamore

In the branches
of an Indiana sycamore
I found my place.

I sat and surveyed
the landscape of hill
and hollow I love.

From this perch
I found my voice
and trilled my song.

Soon it will be time
to begin the long flight
into the blue beyond.

My song I leave
to those who
stay and listen.

Patoka Lake Morning

He descended the long hill,
walked out toward the end
of a swaying long dock,
and sat on a plank bench.

Mist sat on the waters
and nuzzled his cheeks.
Bird cries came and went
from places he could not see.
Now and then, here and there,
he could hear a fish flop.

What he heard and what
he felt rose as prayer
off the waters beneath him.
Gradually, the fog began to lift
and he could see the shapes
of trees arise on a nearby island.
Then, at the far end of a finger
of the lake, as if in a distant
universe, a large red ball rose
slowly, almost imperceptibly,
casting its rays on the waters.

He became aware of the sound
of his breath rising from within
and escaping from his nostrils
as benediction that discovered
the right body for its source,
the right voice for its expression,
in this remote spot that waited
so long and patiently to be
the occasion of his witness.

Woods Chapel

for Oscar Sanchez

In the woods no missal or priest
or lector or choir is necessary.

Every bird cry is a hymn,
the fluff of every squirrel tail

is a consecration, and faith
rises from the ground

to the crown, from stem
to stem of every leaf,

again and again.

Palm Light

for Daniel

Sometimes when we put
ourselves in the right place
in the woods and practice
the patience to wait
with outstretched hand

the sunlight finds
our palm and highlights
the lines crossing its center
so we can begin to read
and appreciate their patterns.

I know you are not
ready to read this now,
but I pray that one day
after I have become
part of the light
it will find your palm
where you stand
ready to receive

and the warm rays
that play on your lines
help move you to step
in the right direction.

A Bend in the Road

Eagle Creek Park

At a bend in the road
two deer stand
in a powder of snow
arching their necks
toward the ground.
They are munching grass
on the day before
the darkest day of the year.

They know we are
in their presence;
their ears pick up,
as if to receive
any frequency
we want to send.

The younger one,
whose winter fur
gives off a sheen
in the cold air,
lifts its head
and lets us spiral
into the darkness
gathered in its eyes.
We can see moisture
lining its nostrils.

Sometimes what is holy
comes walking toward you,
and you must listen
for the fall
of its footsteps.

When the moment passes,
what you see is
a track of imprints
left in light snow.

You know you are lucky
to be breathing
the same air that passes
in and out of creatures
that allow you to
inhale and exhale
in their presence

before they raise
their heads once again
in an arc of grace

and walk back between
the bare branches
of trees whose buds
already are making
ready for the next
birth of green.

In Transit

*site of the Indianapolis International Airport
opening in October 2008*

1

Where you stand in transit
goes back a long way.

There was a forest here where
the Miami lived on the land.

European immigrants reached this spot
and put up cabins in the clearings

they made with their axes where
the first people once sat around the fire

telling stories of how the world began
before many were made to leave

this place where they loved to live.
People brought from Africa to our shores,

to be sold as slaves, came North from cotton
fields to make a new life for their young.

2

People will always come and go here,
as long as we allow the land to endure.

Where you stand has a history
that goes back a long human way.

If you know how to listen, as you stand
here in transit, you will hear voices

of those who have come and gone,
and will enter into our quiet history.

3

Back home on the ground,
we discover that the gift
the great wings gave us

is new eyes to see that
this place where we live
we love more than we knew.

Prayer to Peyton Manning

Hey, hey, Peyton Manning,
please throw me a pass.
You know my moves by heart.
Two sure hands are waiting.
We've taken so many steps
so well together, for so long,
we can do our dance in the dark.

I feel the touch of your finger-
tips spinning the pigskin
toward me even before I make
my cut, turn the corner,
look back for your spiral.

The hometown crowd knows
we move as one wherever
we play, home or away.
They know you always lay
the ball like money in the right
slot for me to fold it in, carry
it safely, take it to the bank.

Hey, hey, Peyton Manning,
please let it go, release,
follow through. No team is
better coached. We know where
the goal line is, how to cross it,
step up to the next level,
enter the Promised Land.

The people are with us.
We are all of one faith,
recite the same litany:
throw me the ball, Peyton,
please throw me a pass.

Fiddler

Once taking a walk
beneath trees in Lockerbie Square,
near the James Whitcomb Riley House,
I heard the sound of a fiddle.

I looked around and up
and saw an opening of sky
and heard the sounds
of a dance in an old barn.

My father, a teenager,
was playing the fiddle
and friends and relatives
were clapping and dancing

and horses were tied
outside the barn and there
was beer in dark bottles
and white lightning

in a clear jug that made
the rounds and rose to
many lips and my father's
bow scraped across the strings.

As the rhythm of his tune
raced faster and faster
women's dresses whirled
and men's feet stamped

and there was one *yee-haw*
after another on a Saturday
night as the grin on my father's
face stretched wide as the sky.

I'm Practically with the Band

for the Spud Puppies, with thanks to Chuck Stevenson

Oh, yeah, I'm practically with the band.
They need dobro, dobro is what I play.
They need piano, I can honkeytonk.
They need mandolin, I pick it clean.
Clawhammer banjo? I can bum-ditty strum.
Lead guitar? I can wail it or understate it.
They need base, I pluck it subterranean.
Fiddle, you bet: slow slurs, racy runs.
They need accordian, I squeeze with the best.
They need a steady beat, I pound the drum.
They need harmony vocals, harmony I sing.
They need lead vocal, I can sing that, too.

Now I ain't sayin' where or how long
I been playin' any or all o' these,
but I'm practically with the band.
I know all their songs so well
sometimes I think I wrote 'em myself.
I own every one of their CDs
and some they won't dare release.
I write and recite a mean original poem
to give the boys in the band a break,
& if they're one song short
I crank out a good one 1, 2, 3.
Now I'm normally a pretty shy guy,
but if the band needs somebody
to swing a sweetheart onto the dance floor
who can shake it like a knockout mixed drink
& make the crowd go wild and wooly,
well, just maybe I could do that, too.

Yeah, I'm practically with the band.
You can color me bluegrass or newgrass,
you can croon me country or rockabilly me,
you can rock & roll me, slide & bottleneck me,

you can murder me with an old mountain ballad,
you can love me tender or hard as you like,
you can lonesome me ever so lowdown and blue.
You all know we are the folk, we are the music.
We are every note, every word of every song.
Oh, yeah, we're all practically with the band.

What Have You Gone and Done?

for Monika Herzig

Monika, Monika,
what have you
gone and done?

You came here
from somewhere else
and showed us
with your pianist's fingers
how to listen to the music
that is pulsing in our veins.

You set Louie Armstrong's
trumpet free to blow
us back to New Orleans
and points way beyond.
We heard and followed
the procession in the streets
and tasted a great gumbo
of musical styles and flavors
that stay on the tongue
and smack on the lips.

You had trumpeter Wynton
of New Orleans tell us
why we already love
what we didn't know
was ours all along.

Monika, Monika
what have you
gone and done?

You came to Indiana
from Swabia via Alabama
and brought us home
to an Indiana Avenue

no longer visible to the eye
but still alive in the sound
of Wes Montgomery's
soulful octaves guitar,
Melvin Rhyne's boogie-woogie
organ in the background,
Everett Greene's alluvial deep voice,
J. J. Johnson's note-bending slide trombone,
Freddy Hubbard's blister-lips trumpet,
Pookie Johnson's sweet-soul saxaphone.

You told us about
the Hampton Sisters dressed
in their Sunday best singing
down South and in Harlem
and coming back home to Indiana
with Virtue slapping the bass
and Aletra singing, from the bottom
of a soul that only goes deeper
as she grows older, lyrics from
the treasure trove of memory.

Monika, Monika
what have you
gone and done?

You showed us it don't mean a thing
if it ain't got that swing,
you brought us Bessie and Billie,
Ella and Sarah and Diana,
the Duke and the Count and Benny,
and Bebop Bird and Coltrane
and Miles' many incarnations.

You led us to the Chatterbox
down Massachusetts Avenue,
brought Cole and Hoagy
alive with your fingertips,
asked us with a smile
to name that familiar tune,
and needled us, with just

the right kind of German sass:
"Come on, it's *your* heritage!"

Monika, Monika
what have you
gone and done?

You laid a flatted fifth
in our ears, let us see
that jazz is beneath our feet
as we walk these streets
and in this American air
as we breathe and the music
will never stop as long
as one heart beats.

On the Road with the Hampton Sisters

Virtue is too frail to slap the bass
and so she stays seated and beats time
on her thighs until Aletra takes off
West to get her kicks on Route 66

and so Virtue, who cannot be left behind,
stands up to the mic and sings along
and the Hampton Sisters are on the road again,
as they were with the Family seventy years ago,

when towns closed to them at dusk
and restaurants and hotels would not open,
but they persisted and they endured,
and now they are singing for us all,

black, brown, white, yellow, red,
and they know the lay of this land
and the topography of the heart
and the geography of the soul,

and their spirit soars unstoppable,
they are both timely and timeless,
inside time and outside time,
carry us with them wherever they go,

and Aletra tells us them that's got shall
get and them that's not got shall lose,
and now Billie's on the road with us too,
and the Sisters tell us what Mama and Papa

may have is one thing, but what God
blesses is the child that's got his own,
and we know now these Sisters have
got their own, and what they got they give

to us, and we are rich and blessed because
we are lucky enough to be here to receive
what God gave us, which is Virtue and Aletra
and soul and spirit and spunk and love galore.

Etheridge Knight's Blues

for Eunice Knight-Bowens

Behind bars you found your voice
and sang your down-home Mississippi blues
about the Avenue that was Indiana,
and you dug Wes Montgomery's guitar
and sang the beauty of the sisters,
but felt the pain of the wound inflicted
in Korea that led to the holes in your arms.

When I walk past the Barton Towers
at 555 Mass. Avenue where you lived
the last years of your life and passed
into spirit when your cells kept exploding,
I think of you on the 13th floor looking out
at the exotic Murat Temple where I heard
B.B. King's guitar hold its drawn-out breath
for such a gut-bucket street singer as you,
and at the red-brick German Athenaeum that
was almost demolished for a parking lot
until it resurrected like the phoenix where
beer-garden music rocks the summer night.

Indiana and Mass. Avenues as you knew them
may be gone, but when sister Eunice took me
and sister poet Allison to stand at your grave
in Crown Hill Cemetery as her persistent way
of keeping your memory, your legacy,
and your song alive, I felt your presence
and knew you a free singer still be, brother.

I love your poems, Etheridge Knight.
I come to honor your spirit that will never die.
I say your song will always be sung
and the blues shall always go on.

Etheridge Knight at the Chatterbox

The moon was round, full, and bright
on Sunday night Mass. Avenue,
the jazz tavern teamed with people,
energy foamed like beer into the street.
Fifteen years after he left us a spirit
that speaks loud and clear, yet soft
and gentle, when we read his poems,
we stood to pay tribute to the flesh
made word of Etheridge Knight.

I thought of Walt Whitman walking
the streets of the city he loved,
riding the omnibus up and down
Broadway, composing his songs
in the tongue of the American folk,
giving voice to our common breath.
Tonight, under a full moon, Walt's
dark son Etheridge was king
of the Indianapolis street, lived
and expressed from the inside.

Born again behind bars as poet-brother,
the Korean vet spoke in a Midwestern
vernacular, with an accent made
in Mississippi, when we recited
and declaimed his words, as a jazz trio
moved us along back to the source,
in a resurrection of spirit that
made us brothers and sisters
of the ragtag Family of Etheridge,
whatever the color of our skin.

We sang our free singer's songs
and clapped for one another and hugged
and said goodnight and walked back

into the light of a full moon
that pulled us into the rhythm
and flow of Etheridge Knight's
luminous haiku of Indiana Avenue.

Song Out of the Dark for Jake Hale

He came to me out of the dark,
as I rushed down the sidewalk late,
longing to hear the music of a singer
whose songs had stayed in my ears
for so many years, so vividly.

He came to me out of the dark
unexpectedly, naturally,
when I was rushing back
downtown after sharing my poems
in another part of town
with another group of people
who love the spoken word.

He came to me out of the dark,
as if he had been waiting to find
me there all of his young life,
and all of my longer life, too,
and the way he spoke was
the message he had to give.

When he came to me out of the dark
on the sidewalk outside of the club
Radio Radio, in Fountain Square,
as I hurried to arrive inside
to hear at least one song by
a Stockbridge Mohican singer
whose work I love and whose
name is Bill Miller, also *Bird Song*,
I did not know that the man waiting
in the dark whose face I could not yet see
had shaped and sung on the stage,
in the tongue of his Lakota people,
an old song for a woman in whose
honor the concert was given,
to celebrate and consecrate
her life, her love, her spirit: Leann,
Sindoqua in her Potawatomi.

As he came toward me out of the dark,
I turned perhaps as if expecting
in the deepest part of me that
I was going to be asked to give
something I wasn't prepared to give,
but he presented the simplest yet
most profound gift it is possible
to give to a poet rushing in the dark
to hear a song by a singer he loves.

Yes, this young singer of a song
he had shaped and sung as a gift
earlier in the autumn evening
stepped up to me in the dark
as I was rushing by, and he spoke,
naming my name and making me
slow down and turn my head,
this singer of deeply felt
traditional song made me savor
every word he had come to say:

"Norbert!" he said, naming me,
saying a name more common
in my ancestral Franconia
than it is on this continent,
giving me identity in the dark.

"I have been reading your poems.
"I am Jake, Robin's nephew,"
he said, naming himself.
"She loaned me your book,"
he continued. "I have been
reading your poems."

Suddenly light flashed
where dark had dominated.
"I like them very much," he said
as he finished singing his second
song of the night, which I make
the conclusion of this song
out of the dark I sing for Jake Hale,

Sings for the People,
the man who helped me
and others with his songs
that came from the heart.

For Kurt Vonnegut, Pilgrim Unstuck in Time

I touch your child's handprint in hard cement
on the slab outside the back door of the house
in Indianapolis where you were born in 1922,
Herr Vonnegut, but like your Billy Pilgrim
in *Slaughterhouse-Five,* you are unstuck in time.

You are your great-grandfather Clement
from Münster who settled here in 1850,
spoke both German and French, left
Catholicism behind for humanistic
Free Thinking, started up the Vonnegut
Hardware Company, married a German farm girl
turned waitress, Katarina Blank, fathered babies
and served on the Board of Education.

Released from time, you are your grandfather
Bernard, who loved to draw and paint, became
an architect, designed the L. S. Ayres Store
at Meridian and Washington, the Herron Art Museum,
the Chamber of Commerce, Das Deutsche Haus,
the red-brick center of downtown German culture
demoted in World War I to "The Athenaeum."

Your child's handprint remains caught in cement,
but like Billy Pilgrim you are unstuck in time.
You are your father, Kurt Senior, an architect
who studied at Short Ridge High School, three
more years in Strasbourg, loved German classical
music, got a degree from MIT, spent time in Berlin,
lived in New York, came back home to Indianapolis,
married Edith Lieber at the Claypool Hotel, corner
of Illinois and Washington, 600 guests at the wedding—
75 men and 10–15 women of whom they say passed out.

Like Billy Pilgrim, Kurt, you passed outside of time
but your child's handprint stays with us in cement.
At Short Ridge High School you edited the newspaper,

were told you must study science to get a good job,
became a WW II prisoner in an underground slaughter-
house in Dresden when firebombs fell, survived,
became an architect of words and imagination
who learned to unstick stories and characters in time,
freeing them to time-travel through the universe.

The child's hand that left the print in cement
wrote the words that travel across the times.
You once upon a time lived in New York City
and on Eastern Long Island but came back home
in your books to this state and city where you live
forever in your unbound, unfettered words,
our Free Thinking, Hoosier German pilgrim.

Spring Waters

Whenever I close my eyes
I return to a creek in the woods.
It may be the same creek
each time, or several creeks
may merge in memory
to become one. Always I kneel
down, cup some clear water,
and splash it on my face.
Sometimes, when I am thirsty,
I cup the still-pure water
and sip it until I have
had my fill, then sigh.

I may not have time to lead
you back to the source
of this life-giving water,
but I am sure you can
find it by yourself if only you
close your eyes, listen, and let
your feet step in the woods
wherever you are called to go.

You will know where and when
to kneel. You will see and hear
the quiet bubbling up of pure water
between brown leaves. You will
cup your hands in just the right way,
lift a small pool of that cool water
to bathe your face, and sip it slowly.
What you taste will come from
within where I live at the source.

Photography Credits

All photos were taken in towns and counties in Indiana.

About the Author

Jasper native Norbert Krapf, a Pulitzer Prize nominee, was Professor of English at Long Island University from 1970 to 2004. His recent work includes the childhood memoir *The Ripest Moments; Invisible Presence*, a collaboration with photographer Darryl Jones (Indiana University Press, 2006); and a jazz and poetry CD with Monika Herzig, *Imagine—Indiana in Music and Words*. More information is available at krapfpoetry.com.

About the Photographer

Before moving to Chicago, David Pierini was a staff photographer for *The Herald* in Jasper, Indiana for ten years. He was named Newspaper Photographer of the Year in 2003 and 2006 by the Indiana News Photographers Association and has won several state and national awards for photography and photo editing. His work has appeared in several national magazines, the *New York Times*, and three books: *America 24/7* and *Indiana 24/7* by Rick Smolan and David Elliot Cohen, and *Photosynthesis* by Bryan Moss.